THE DOG, THE WOLF AND GOD

FOLCO TERZANI

THE DOG,
THE WOLF
AND GOD

ILLUSTRATED BY NICOLA MAGRIN

WILLIAM
COLLINS

William Collins
An imprint of HarperCollinsPublishers
1 London Bridge Street, London SE1 9GF
WilliamCollinsBooks.com

First published in Great Britain in 2019 by William Collins
This edition published by arrangement with Longanesi & C. © 2017 –
Milano Gruppo editoriale Mauri Spagnol

1

Text Copyright © 2017 by Folco Terzani, Illustration Copyright © Nicola Magrin
Folco Terzani asserts the moral right to be identified as the author of this work
in accordance with the Copyright, Designs and Patents Act 1988

A catalogue record for this book is available from the British Library
ISBN 978-000-832599-2

Cover design by Heike Schuessler
Layout by Susanna Hickling

Typeset in Minion Pro

Printed and bound in China

This book is produced from independently certified FSC paper to ensure
responsible forest management.
For more information visit: www.hapercollins.co.uk/green

To my dear lost friend
great king Kapil

Contents

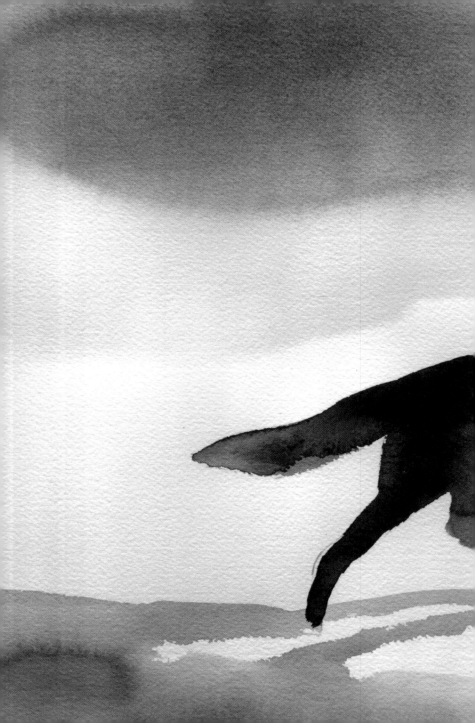

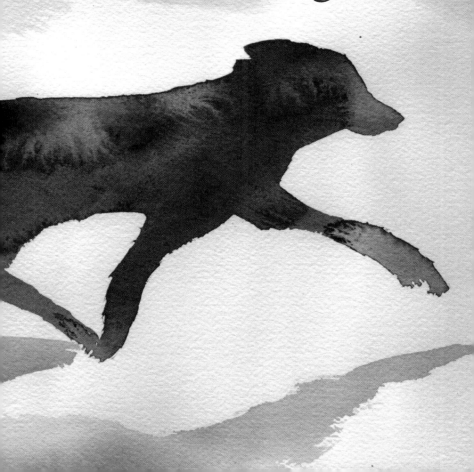

PART ONE

The Dog

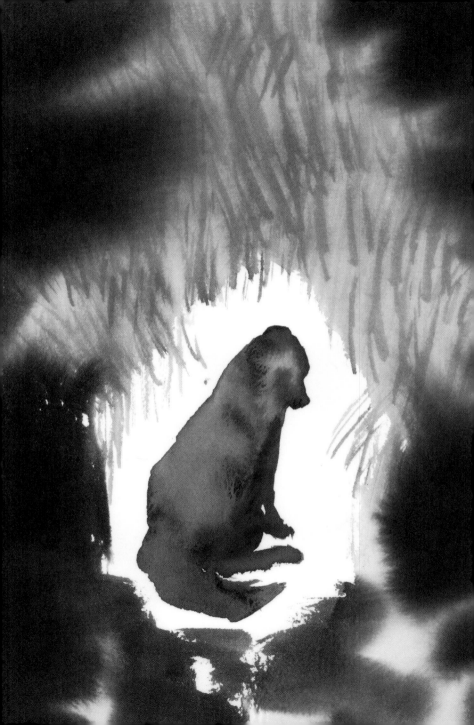

CHAPTER ONE

Abandoned

A dog stood by the side of a road. His Owner had removed the shiny collar he'd worn with pride ever since he was a pup, pushed him out of the car and sped away, leaving him there. All alone. The poor creature, who couldn't make head or tail of what was happening, remained rooted to the spot, under a streetlamp, without moving an inch.

If my Owner has left me here, he reasoned, *surely he will soon return.*

An hour went by, then two and then four more. But of the Owner, not a trace. With a soft hum the streetlamp turned on, casting a pool of yellow light around the Dog beyond which darkness fell. The Dog scrutinized each car that went by, looking for that familiar face. His ears turned towards every sound, hoping to hear that voice calling his name. But all he heard was the heartless throb of engines and all he saw were the big blind eyes of cars zooming by.

Nobody stopped, as if they hadn't even seen him.

For three days and three nights the Dog waited, without eating or drinking or sleeping. Finally he was so worn out that his head sank, his ears flopped, his eyes misted over and he began to cry. It was only a feeble wail at first, but as the full extent of his troubles became clear, the sobbing grew desperate and he surrendered to the infinite sadness of life. And he would surely have remained there, under that streetlamp, crying himself to exhaustion – to death, even – if at dawn he had not heard a voice.

'Why are you crying?'

The Dog was surprised. The voice came from right beside him, yet he hadn't heard any steps approaching and no car had passed for some time. So he didn't even bother to raise his head. He'd just imagined it, probably.

'Why are you crying?' he heard again.

It was a deep, resonant voice with a thick foreign accent. Who could it be on this road in the middle of nowhere? It wasn't his Owner, in any case, so the Dog just went on wailing.

'Why are you crying?!' said the voice once more, and this time it demanded a reply.

'Why?' blurted the Dog. 'Because I have lost everything that I had.'

Looking up, he was amazed to find before him a very strange dog indeed, the likes of which he'd never seen before. He had wide paws, firmly planted on the ground, a gaunt body and a huge head with two big golden eyes that were staring straight into the Dog's soul.

Intimidated, the Dog tried to explain himself better.

'I had an Owner,' he began between sobs, 'who I lived with since I was born and loved as a father. Every morning, when my Owner awoke, I followed him to the kitchen where he filled my two bowls, one with water, the other with food. At night, when he went to sleep, I curled up at the foot of our soft bed and kept watch over him. He gave me everything. Now my Owner is gone. Where is my house and my bed? Where are my bowls? Even my beautiful collar, which had my name and address on it and was my most treasured possession, has been taken away. No one can know who I am any more, or where I come from. How

'Why?' blurted the Dog.
'Because I have lost
everything that I had.'

will I ever get back home? I'm alone, in a place I've never seen before. And I have nothing. Nothing at all! And you ask me why I'm crying?'

The other creature gazed back with a regal look, but remained silent.

'What shall become of me?' continued the Dog. 'I haven't even got the strength to stay upright any more, but where can I lie down to rest? And who will give me food and water? Oh, oh, oh, I know I'm going to die!'

'So that's your problem. Is that all?' The other's lips curled into a smile, as if the Dog's plight were a matter of no importance. 'But don't you know that in this world there

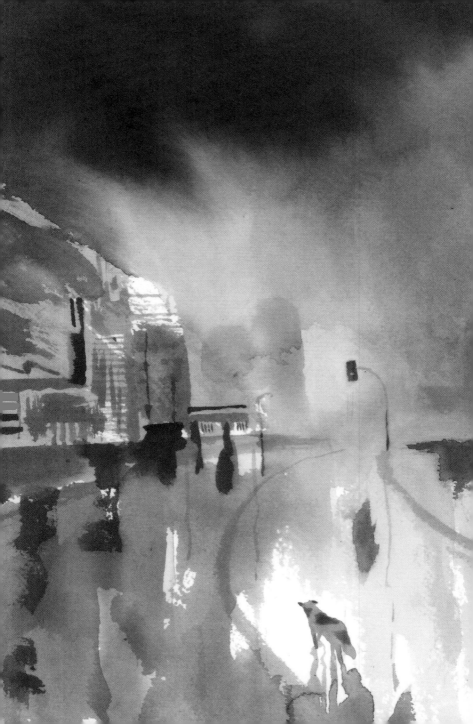

are countless creatures, great and small, who live on the land, and in the air, and in the seas, who wake up every morning with nothing, nothing at all. Just like you. The ants and the butterflies, the fish and the eagles and the snakes and the bears. And yet, by the end of the day, they've all had something to eat and drink. And when they become tired they even find a comfortable place to lie down and rest. How, do you think, does that work?'

The Dog remained so dumbfounded for a moment that he didn't even realize he'd stopped crying.

'Who is *their* owner?' continued the stranger. 'Who, do you think, is looking after them?'

'I don't know,' retorted the Dog. And he'd have liked to add, *And I couldn't care less either!*

In truth the Dog had never thought much about all the other creatures in the world and right now he was far too worried about himself and his own troubles.

'Who?' the other persisted, his glowing golden eyes seeming to bore right through him.

'If you know,' said the Dog, 'then why don't you tell me?'

The strange dog rolled his eyes skywards and emitted a peculiar sound, something between a sneeze and a sigh.

'Who?' asked the Dog, becoming increasingly confused.

'That cannot be said. It is the Name unspeakable. It is that which as soon as it's said immediately becomes a lie.'

There was a long pause.

'Bah,' snorted the Dog at last, impatiently. 'All you have to do is take a look around to see how much suffering and misery there is in this world.' He was feeling very sorry for himself. 'There's clearly nothing and no one looking after

all living things. If there is something, I for one have never set eyes on it, never heard its voice, or even smelled it. In fact, judging by the stink everywhere, if something ever did exist, now it's certainly dead.'

'Ahh . . .' said the other, as if understanding at last the answer to a complicated puzzle. 'Your problem isn't that you've lost everything. You have lost your trust!'

The stranger turned and raised as if from nowhere, in his long sharp fangs, the still-bloody leg of an animal.

'Here,' he said, laying it in front of the Dog like a precious gift. 'Eat this. It will restore your strength. Then, go on a pilgrimage to Moon Mountain. And when you reach it you will know if there is Something, or not.'

A Gift and a Bond

Moon Mountain, the Dog pondered. *Now what's this all about?*

Meanwhile, a fragrance so pungent and exotic was wafting up from the stranger's gift that the Dog couldn't resist examining it at once. It was, undoubtedly, a large chunk of fresh meat, covered in fur. The hind leg of some wild animal – maybe a deer, he thought, judging by the little hoof at the end. But being a city dog, he was really no expert on such matters.

In any case, everything that was happening to him was very odd. He would never have imagined receiving such a generous gift from a perfect stranger. Dogs snarl and bite just to defend a dry old bone. Never ever had he seen a dog casually give away his entire meal – and such a sumptuous one, at that.

Who is this strange dog, really?

And suddenly he understood.

But when he raised his head to look at him again, the Wolf had already vanished.

Now the Dog found himself in a serious quandary: should he eat this meat, or not? Because everybody knows that you shouldn't trust a wolf. On the other hand, three long days without food had made him ravenously hungry.

I'll try just a tiny little piece . . . he thought.

As soon as his teeth sank into the tender meat a warm liquid, at once salty and sweet, dripped over his tongue and slipped down his throat and deep into his belly. It tasted of

Now that he'd accepted his gift, the Dog felt bound to do as the Wolf had told him.

things forbidden, and the Dog felt bewitched. Back at home his beloved Owner had cooked their meals, or given him tins of food and dog biscuits, so the Dog had never known raw meat before. This deer leg seemed to the Dog the most delicious thing he'd ever tasted.

After the first bite he threw himself on it with such relish that he would surely have gobbled the whole thing up in one go if the meat hadn't been so exquisitely rich, so nourishing, that very soon he was completely full.

He burped.

Well, that was certainly a stroke of luck! he thought to himself, beginning to feel new strength trickling through

his veins. *But these things don't happen every day. Half of the Wolf's gift is already gone, so I must be extremely careful to ration what's left, otherwise what will I eat tomorrow? Or the next day, and the next . . . until I finally find my way back home?*

The moment his thoughts wandered back to his comfortable home, however, he remembered the words of the Wolf. Now that he'd accepted his gift, the Dog felt bound to do as the Wolf had told him.

But where that Moon Mountain might be, he didn't have the foggiest idea.

A Friend for the Journey

Having double-checked and checked once more to make quite sure that no one was spying on him, the Dog dug a hole beside the streetlamp and buried the remaining half-leg of deer. Then he picked a direction at random and set off with a newfound spring in his step down the unknown road. After a short trot he came to a park. On the manicured green lawns scores of dogs were sunning themselves, or jogging patiently beside their owners, or playing the age-old game of 'fetch'. A stab of sorrow pierced the Dog's heart as he remembered what he too had once enjoyed, and lost.

Plucking up courage, he intercepted a poodle who was sauntering by.

'Excuse me,' he said. 'I am not from around these parts. Could you tell me the way to Moon Mountain?'

She looked him up and down as if he were quite mad, then turned tail and sprinted back to her owner as fast as

her puffy legs would carry her.

The Dog was bewildered. He'd always been a highly respected fellow: youthful, handsome, with his neatly brushed coat and twinkling collar . . . No, no, no, that was it – he didn't have his collar any more! All of a sudden he felt completely naked. Like a king without a crown, or a swimmer who realizes he's lost his bathing suit. It may seem like a trivial item, but it changes everything. Seeing him without a collar, the poodle had taken him for a stray. And every good city dog knows that you should never talk to strays, for they carry fleas, and ticks, and mange, and rabies, and all sorts of other horrible diseases.

Oh, I'm in trouble now! realized the Dog, as he slunk behind some bushes to ponder what to do next.

He thought and he thought, but no idea came. Instead, after a while, he spotted an old mastiff coming his way, followed by a cloud of flies. The feeble fellow kept snapping at the air, but try as he might he never caught a single one of his tiny tormentors.

Perfect, thought the Dog, *that's exactly what I need!* So he risked stepping out from behind the bushes.

'Excuse me,' he said. 'Could you tell me the way to Moon Mountain?'

'No, I cannot tell you, for no such place exists around here,' replied the mastiff very politely, his almost blind eyes seeing nothing at all wrong with the Dog.

'That's impossible, for I just met a . . . a strange fellow who told me I should go there.'

'Well,' said the old mastiff, after some thought, 'long ago, when I was a little pup, I *did* hear tell of a place with such a

name. But it was way, way up in the north, they said. North beyond the Northwoods . . .'

The Dog, who'd assumed his destination was somewhere close by, was dismayed. Why would as noble a creature as that Wolf have wanted to mock him, sending him on an impossible journey? There must be some mistake.

'Could you tell me, please,' he said, deciding he would continue nonetheless, 'which way is north?'

'Certainly. Wait till midday, turn your back to the sun, then continue walking in the direction of your shadow.'

The Dog thanked him and hurried back to the streetlamp and by the time he'd dug out his half-leg of deer it was exactly midday. So he turned his back to the sun, looked to see which way his shadow was pointing, and began to follow it.

Head bent low, half-leg of deer clamped between his jaws, he crossed the busy city, trying his best not to attract attention. He slunk through traffic, slipped over bridges and crept furtively along the walls of houses. From behind a window pane a ginger cat hissed, while countless dogs yelled their usual unpleasantries: 'Bow-wow, bow-wow, you get off my turf now!' It was as if he were in a foreign land: not a street corner he recognized, not a patch of grass that smelled familiar, not a pee nor a poo that he knew.

Many times he was assailed by doubt. *When I finish this meat, I'll have nothing to eat once more. Nothing at all! Then what will I do? It would be much wiser to turn around and*

try to find my way back home. The Wolf will never know and... But each time, the memory of those serious, golden eyes forced him to press on.

It was a big city and it took a while to reach the suburbs, where the houses shrank and thinned out and the Dog's gaze could finally stretch into the distance where he saw a colourful mountain of . . .

Just then a golden retriever, with long blond fur and a winning smile, came bounding towards him.

'Hello, my friend!'

'Hello,' answered the Dog, who was longing for company. And they began to chat.

The Dog recounted his misfortunes and as he did so tears welled up again in his eyes, for he worried about his beloved Owner who had not returned and to whom something terrible had surely happened.

'Don't kid yourself,' interrupted Golden. 'Your Owner's perfectly fine. He simply had enough of you, never wanted to see you again and moved on. Why else would he have taken your collar?'

The Dog's eyes widened in fear, for deep down he knew that Golden was right.

'I was also abandoned, years ago,' continued Golden. 'Still I get by, eking out an existence from that heap over there.'

He nodded towards the colourful mountain behind him.

'Is that a mountain ...?' asked the Dog timidly.

'It's a rubbish dump!' said Golden. 'Maybe it's not the best place, but you know what they say, beggars can't be choosers.'

'Oh. I can't stay then, since I have to go to Moon Mountain. But some say it's this way and some say it's that way and some say it doesn't even exist. I don't know what to do any more.'

'You know, I've always wanted to go there too. Let's go together!'

'Really?' said the Dog, who could hardly believe his luck. 'Isn't it too far?'

'Not at all – I know a shortcut. The only problem is that you're carrying a very heavy load. Obviously you're a city

'You see, when you carry something uphill its weight doubles, and after a while it doubles again.'

dog who knows nothing about mountains. You see, when you carry something uphill its weight doubles, and after a while it doubles again. You'll never make it.'

'Then what shall we do?'

'Don't worry,' said Golden, flashing another of his winning smiles. 'If we share the burden, it'll be easy. I'll take it first, so you can have a rest.'

So the Dog gave Golden the precious half-leg of deer and the two of them set off together, happy to have found a friend for the journey.

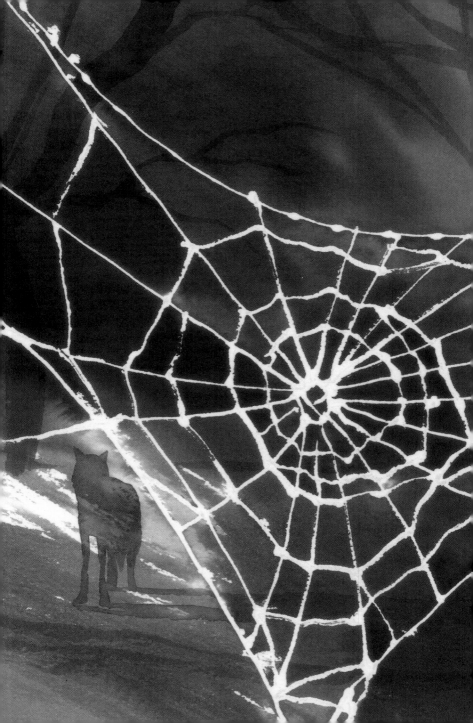

CHAPTER FOUR

Taking the Shortcut

The road that led out of the City swarmed with trucks that blew their horns angrily and exhaled their noxious fumes at the two wayfaring hounds. So it was a relief when the main road turned off into a smaller road, which turned into a dirt road, which narrowed and narrowed till it came to an abrupt stop at the edge of a wood. There a mountain path began, its entrance barred by a giant spiderweb.

It was clear that no one had gone through there in a very long time.

'Come on, what are you waiting for?' said Golden. 'We've got to take this path.'

The poor Dog hesitated. He was used to going for walkies with his Owner around the block, or at most for a run in the park. This place was altogether different. It gave him the creepy feeling that here the dominion of the City ended and they'd be stepping into a different realm. He took a deep

breath, closed his eyes and pushed through.

The path was rugged and uneven, strewn with loose rocks and unpredictably twisting roots, so it took a while to get used to. But soon the din of traffic faded, the air was fresh and the infinite shades of forest green were a balm for his eyes. The Dog rushed about happily, sniffing the different grasses and flowers, listening to the chirrup of insects and birds, and it seemed to him that in the whole of nature not a colour was mismatched or a single sound was out of tune.

'Tell me, my friend, what is it like on Moon Mountain?' asked the Dog.

But when he turned, Golden was nowhere to be seen. How odd, strong as he was, that he should have fallen behind. The Dog carefully retraced his steps only to find Golden lying in a sunny glade, tearing a chunk of meat off the leg of deer.

'What are you doing?'

'Just helping reduce your burden a little,' replied Golden, flashing his smile. 'And besides, I only had a very measly breakfast this morning. If you want me as your guide, I need a bit of energy too, don't I?'

The Dog considered this a reasonable deal, though he realized to his dismay that only a quarter of the precious gift now remained.

'All right,' he said. 'But do please hurry up or we'll never get there.'

Yet in spite of the fact that the Dog knew nothing about mountains, somehow it was always Golden who was lagging behind.

'Don't worry,' panted Golden. 'We'll reach Moon Mountain by sunset and then all your troubles will be gone. There are goodies in abundance up there, herds of juicy little deer and delicate porcupines without quills . . .'

'Really?'

'And trees so laden with fruit that their branches hang to the ground.'

'No!'

'Absolutely, and that's not all. You can eat everything there, even the rocks, which twinkle like jewels and melt when you put them in your mouth.'

'The rocks melt, how can that be?'

'Because up there it's the fountain of life, my friend! Oh, you'll see, you'll see.'

Just then they came to a fork in the path. Golden wavered for a moment before taking the trail to the right. Unfortunately it soon ended in a field of thorns.

'I thought you knew the way.'

'Can't you see this is a dead end? We should have gone the other way. And stop wagging your tail, it's confusing me!'

The Dog was beginning to have a creeping suspicion about Golden's shortcut, but at this point they'd come so far that it was better to keep going than to turn back.

Shortly afterwards the Dog again caught Golden nibbling at the remains of the deer.

'Hey, that's *my* leg!' he cried indignantly.

Golden slowly finished chewing the piece in his mouth.

'Yours?' he replied, pulling with his tongue at a fibre that had wedged itself between his teeth. 'Yours? Didn't you tell me that this morning you were all alone, with nothing in

the world? So how can it be *yours*? Didn't a Wolf then come along at dawn and gift it to you? In that case, if anything, it was his. But let's be honest: it can't really have been *his* either because before that, surely, it must have belonged to a deer, no? Therefore all this business about "mine" and "yours", what does it mean? In the end a thing simply belongs to whoever's got it!'

Thus chewing and reasoning, Golden had polished off the last of the meat. When the Dog stepped forward to retrieve the bone at least, Golden again showed off his fine white teeth – this time, though, in a far less friendly way.

The Dog decided to let the matter drop and started up the hill again. Once in a while he turned to call Golden, but as no answer came he soon realized that his companion had vanished.

The first day of the journey wasn't even over yet, but already the Dog had squandered the Wolf's gift. Again he was all alone, with no Owner, no home, no food, nothing. Nothing at all. In fact, his situation had become even worse now because, instead of being in a city, he was lost in the thick of a great big forest.

Hoarse laughter broke out from the top of a nearby tree. A gang of jet black crows – with black feathers, black beaks, black claws and black eyes – were mocking him. Their ugly cawing stood out as the one sour note in the great harmony of nature.

CHAPTER FIVE

Abundance

The day had grown steadily hotter and by mid-afternoon even the fluffy flock of clouds that grazed on the sky had melted away. The sun beat down mercilessly. Not a breeze blew, not a leaf stirred. The Dog had been walking for so many hours that his throat was parched and his tongue hung from his jaws like a dead fish. He'd never been so thirsty in his life.

What an absurd place, he thought. *Not a drop of water anywhere!*

He reminisced about his clever Owner who always brought a backpack along, with some tasty snack wrapped in a red and white checked cloth and a flask full of water.

But I am just a stupid dog . . . How foolish he'd been to set off on this adventure, following the words of a wolf. *The Wolf said that leg of deer would give me the strength to reach Moon Mountain. But the meat is already finished, and*

there's no trace of the mountain. So I don't owe him anything any more, thought the Dog. *I'm stopping here!*

As his breath quietened and his heartbeat settled the Dog began to hear an alarming hiss. But if it was a snake, it neither came closer nor moved away. Fear gradually turned to curiosity and the Dog heaved himself onto his paws to peek around the next bend. He was stunned to find himself on an old stone bridge suspended above a mountain torrent, which came frothing forth in a marvellous waterfall, over which a beautiful rainbow hung.

'He was stunned to find himself on an old stone bridge suspended above a mountain torrent...'

Oh, it was like a mirage!

The delighted Dog danced with wild abandon; he'd never seen so much clear, sparkling water. The air was filled with its fragrance and the greenish rocks seemed redolent with the promise of fertility. It was nothing at all like the piddling little water taps he'd known in his kitchen back home.

'This flow of water never ends!' he cried deliriously. 'Where does such abundance come from? What a glorious folly, what a waste, what a miracle! Why, there must be enough water gushing by here to quench the thirst of every living creature in the world!'

Shaking himself out of his rapture, the Dog dashed across the bridge to climb down to the torrent. But the walls of rock were too steep and he couldn't risk falling because he didn't know how to swim. So he raced back over the bridge and tried descending on the opposite bank, but there too the mossy green rocks were slimy and sheer and when he persisted his paws slipped and he fell hard on his back and was lucky to get away with just a nasty cut.

The Dog was dying of thirst and it drove him mad to see all that water down below, which seemed to be laughing and playing, and not be able to reach it. Yet there was nothing to do but leave it and continue on his way.

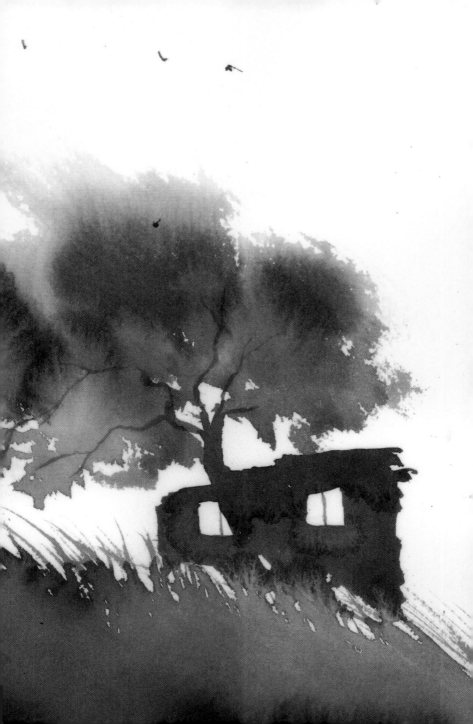

The Beggar's Bowl

Sitting on a rock with a distant view, the Dog tried to think. A few days ago life had been so simple, but ever since he'd accepted the Wolf's gift things had taken such a peculiar turn that he couldn't avoid asking himself 'Why?' and 'How?'

The truth was, though, that the Dog wasn't used to asking himself many questions because he'd always left it to his Owner to know the answers. Now that his Owner wasn't around, could he, on his own, find that unspeakable Something which every day takes care of every living being? And, more importantly, would it really take care of him too?

He took a deep breath and set off again on the path, one step at a time, until he came upon a small group of houses. They seemed as abandoned as the fields surrounding them. He couldn't hear the barking of dogs, or the grunts of men

*The Dog was overjoyed
to see a human again and tried
to communicate using every
trick he knew. He waved his
tail and whimpered, he bent
his knees, dragged himself
along the ground and begged
with his pitiful eyes...*

and women at work, or the laughter of children at play. The trees of the forest had silently crept into the living rooms, poked their heads through the roofs and waved their leafy hands out of broken windows.

'Water, water, water!' barked the Dog in desperation.

His voice echoed around the derelict walls. Suddenly a window above him burst open and out leaned an old woman with long, tangled hair.

'Whatchoo want?' she yelled, with the tone of someone who's been woken from their afternoon nap.

The Dog was overjoyed to see a human again and tried to communicate using every trick he knew. He waved his tail and whimpered, he bent his knees, dragged himself along the ground and begged with his pitiful eyes, all the while

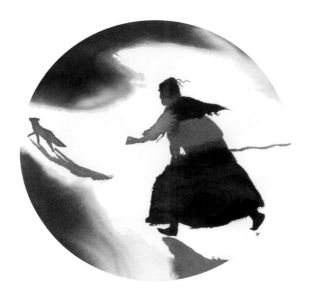

repeating what he'd been saying from the start: 'Water, water, please give me a bowl of water!'

What else could he do? His Owner would certainly have understood.

The window slammed shut.

The Dog's tail dropped between his legs, his ears fell and he lowered his head. And as he did so he noticed once more that the sparkle of his collar was gone, that his paws were caked in mud, that his fur was dishevelled and plastered with blood from the fall, that in barely a few days of living on his own he'd become a poor, ragged stray. A beggar. One of those wretched creatures that have neither beauty nor joy to offer and so are of no interest to anyone.

Never had he imagined that he, who'd once been a

respectable dog, could fall so low. How quickly our destinies can change!

He was just about to start crying again when he heard the *clank-clank-clank* of an ancient lock, a door swung open and the old woman emerged holding a bowl brimming with water.

It was a rusty bowl, with holes in it too. But in the moment when she laid it before the Dog he understood that this common liquid, which he'd always taken for granted,

Never had he imagined that he, who'd once been a respectable dog, could fall so low. How quickly our destinies can change!

which now flowed down his parched throat like medicine for his aching body, was actually the elixir of life. It was the most magical potion in the whole world.

The Dog threw himself at the old woman's feet. In a flash he imagined himself staying here with her. She would adopt him and be his new Owner. And he would keep her company and listen to her stories when she was sad (he was an excellent listener, even when he didn't understand every word). And she would rub his ears. And he would live in this derelict village, close to the woods, which he

could explore . . .

He was so happy, and still so very thirsty, that he leapt up to lick the old woman's face. She got a fright, seized her stick and struck him several times on the head.

'Go away, you filthy beast! You've had your water so don't you be hanging round here for more. I got enough troubles of me own without some lazy good-for-nothing like you. Go away, shoo, shoo!'

The Dog obeyed, as he'd always obeyed humans and, with a heavy heart, ran away from the quiet little village.

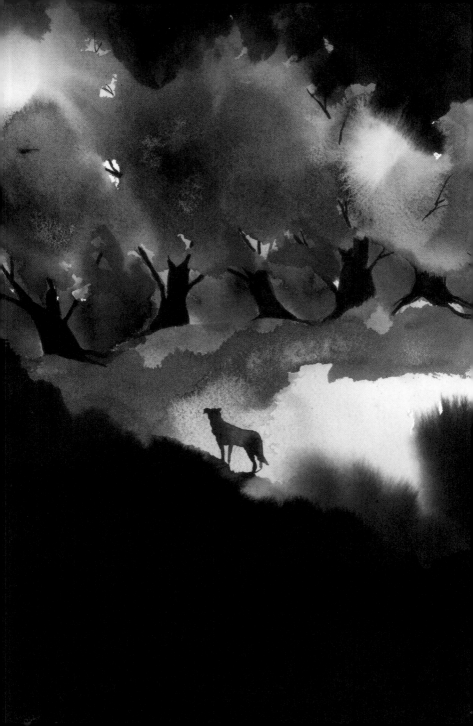

Then Comes Night...

The path kept getting steeper and rockier.

It can't be much further now, thought the Dog to himself.

But when he rounded the next bend he found that the path kept on going and when he reached the top of the hill all he could see was a vast forest that spread out in every direction. Of that place of infinite abundance he expected to find, not a trace.

Oh, how big this forest is! Aren't there any more villages anywhere? Any humans? What am I going to do?

Always thinking he was almost there, the Dog continued on his journey. Little did he know that in the mountains night falls swiftly, and suddenly the sun had set and it was dark.

Fear gripped him. How would he survive, alone, in a forest, at night?

With the departure of the sun everything was trans-

formed. One world gave way to another. The bright colours were reabsorbed, one by one, into the objects they'd come from and that green, vibrant forest became as creepy as a graveyard. The purple and yellow flowers that had lined the path huddled into themselves, closing their petals. Their fragrance vanished from the air. Even the sounds changed. No longer could he hear the constant rustling of lizards and leaping of grasshoppers that had kept him company all day. The merry trilling of the birds subsided and a great silence spread across the land, interrupted only by an

> *Oh, what a stupid dog I am! he thought. What am I doing, wandering in the night, in the middle of a forest?*

occasional eerie 'Ooooo-ooooo-ooooo. . .'

Hopefully just the hoot of a distant owl.

The birds had flown back to their nests. The mice had vanished into their underground burrows. But where could he, the Dog, lay his weary head?

Oh, what a stupid dog I am! he thought. *What am I doing, wandering in the night, in the middle of a forest? I'm a city dog and this isn't where I belong at all.*

As the shadows thickened he scoured the land for some kind of shelter, but there was absolutely nowhere to his liking. This place was too rocky, that place was too leafy

(and housed an irate scorpion that came prancing out with its sting waving in the air), another was horribly dirty – in the sense that it was actually made of dirt . . . Oh, how he missed his soft, clean bed at home!

By now it was pitch dark. Without realizing it the Dog, who couldn't see where he was going, had wandered off the path, and when his fur caught against a thorn bush he imagined he'd been seized by the claws of a savage beast. Panicking, he sprinted off like a thing possessed, went crashing into a large rock, escaped from the rock, ran into a tree then fled yelping from the tree, did a somersault, lost all sense of direction and just kept on running and running and running . . . until his front left paw sank into the void. Only then did his other paws freeze. The chill wind that blew from below whispered that he was on the edge of a cliff.

One more step and I'd have tumbled into the jaws of death! he told himself. *I must pull myself together.*

Then he remembered the deep, confident voice of the Wolf he'd met that morning. 'Don't you know that in this world there are countless creatures, great and small, and when they become tired they find a comfortable place to lie down and rest.'

As soon as his thoughts changed and a germ of trust began to grow, the very rocks he was standing on lit up with a pale glow. A sickle moon peeked out from between scurrying clouds, illuminating the ragged silhouette of a ridge. Slowly, very, very slowly, he pulled back from the cliff edge, and turning his head he spotted a tiny flash of light. It went out. Flashed again a little further off. Went out.

*Surrounding the clearing
were seven great trees,
their silver trunks shining
in the moonlight.*

Flashed again…What was it?

The Dog started to follow the little light and before he knew it his feet felt a path again and the path became mossy and soft and the canopy of leaves opened above his head and he found himself at the edge of a clearing where a thousand fireflies were dancing.

Surrounding the clearing were seven great trees, their silver trunks shining in the moonlight.

By this point the Dog was utterly exhausted. He hadn't slept for days and had endured so many misadventures that his paws refused to take another step. Without caring if it was clean or dirty he fell to the ground, right there where he happened to be standing. And as soon as his eyelids closed, he was fast asleep.

CHAPTER EIGHT

Wolves!

Terrible screams rang out as a hail of rocks hit him on the head.

He woke with a start to find himself in a bright clearing full of little flowers fluttering in the breeze. With a gentle hum the bees were doing their usual rounds. The sun was already high in the sky. It was late morning.

The night had passed and, somehow, he was still alive!

The Dog stood up, stretched his limbs and shook the earth out of his fur. That was when another 'stone' fell on his head. Looking up into the canopy of the silver trees he saw they were decorated with countless little red balls. Cherries!

Feasting on these forest candies was the gang of black crows, who swallowed them whole, one after the other. Now and then, though, they'd let one drop on the Dog, which is how they'd woken him up. He barked

furiously at the ugly birds until a perfectly aimed cherry fell right into his mouth and, biting into it by mistake, he discovered how wonderfully delicious it was! Each one of those wild fruits contained a sweet drop of juice and when he'd swallowed some fifty or more his thirst was quenched and he'd had a very decent breakfast indeed.

There were still many ripe cherries on the ground and he would have loved to take them with him. But being just a dog, with no backpack and no pockets to put them in, he reluctantly bid them goodbye and went on his way.

> *There were still many ripe cherries on the ground and he would have loved to take them with him.*

In front of his nose, a pair of lovesick butterflies chased each other through the air in ascending and descending spirals.

'Lucky you,' mumbled the Dog. 'Yesterday I thought I'd found a new friend, today he's already gone. Golden might not have known where Moon Mountain is, but he was right about one thing: I can't go back home. No human wants me any more; the last one I met beat me with a stick and shooed me away.'

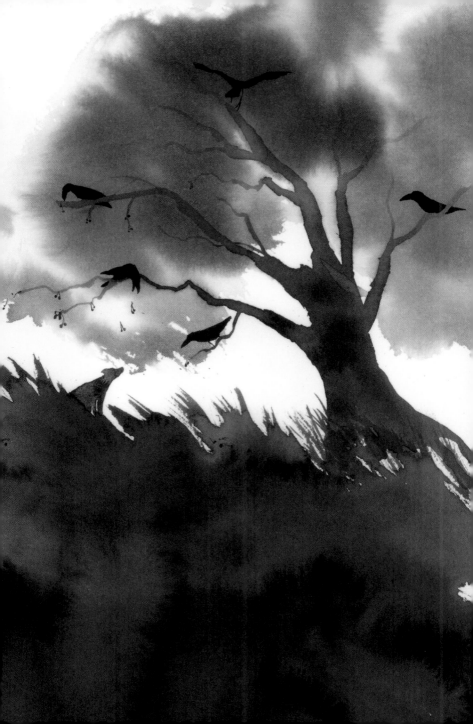

The Dog walked for many hours, till once more the day grew hot and the sun beat down mercilessly and his tongue hung from his jaws like a dead fish.

Cherries are all very well for birds, he thought anxiously. *But not for a big dog like me. Who's going to help me now?*

Since there was no one to turn to, the Dog cleared his throat and started talking to himself at first, then, louder and more clearly, to no one in particular. 'I don't even know your name. I've never seen you, or heard you or smelled you. I don't even know if you're there. But I'm a stupid dog, you see, lost in a forest and I'm hungry again. Please, if you can hear me, will you give me something to eat?'

The words had barely left his lips when he found himself in front of the most terrifying set of creatures he'd ever laid eyes on. Their wild appearance, unkempt fur, long sharp teeth and bandit stares left no doubt as to who they were. He was surrounded by a pack of wolves.

The Dog tried to retreat behind some shrubs. Too late.

'Hey boy, come over here! Food.'

Food? They wanted to eat him!

A black wolf, bigger than the others, stepped out of the pack and came so close the Dog could feel his breath on his muzzle. He smelled of rocks and moss. His eyes had that cold, unforgettable look wolves have the first time they meet you, when they're deciding whether to eat you or not.

'I-I-I'm sorry . . .' stammered the Dog. 'I have nothing. I'm just a poor, stupid dog who's lost everything.'

'Oo-ooo, I wouldn't say that,' said the black one. 'You've got a bit of meat on you still!'

The other wolves broke into howls of laughter.

An elderly wolf, with white hairs on his snout, emerged from the pack. 'Come here, boy,' said the calm, soothing voice. 'Come, eat with us.'

Only then did the Dog notice, right beside them, the corpse of some kind of hairy pig. Finally he understood: rather than wanting to eat him, these gaunt characters were actually *offering* him food.

How very strange, thought the Dog. *I'd just asked for food and the very next words I hear are, 'Come, eat with us!'*

Like a family sitting around a table, the Dog and the wolves took their places around the dead beast and together

I'd just asked for food and the very next words I hear are, 'Come, eat with us!'

they began to dine. There was something very intimate and familiar about sharing a meal with the pack and the Dog felt quite moved.

These wolves, the Dog discovered, could gobble down vast amounts of meat. They'd stuff themselves, go for a little wander to stretch their legs, then come back and stuff themselves some more. The pig was fat and succulent, so pretty much all of it was good to eat, except for the bones and its hairy hide.

'Excellent, this wild boar,' said the black wolf, whose name was Kalu. 'But I'm still hungry. What else have we got?'

*'Why is it never enough
for you?' retorted Alina,
the she-wolf.
'Crack yourself a bone.'*

Licking red splashes off his muzzle he looked straight at the Dog, who instantly cowered, making himself as small as he could.

'Why is it never enough for you?' retorted Alina, the she-wolf. 'Crack yourself a bone.'

Fortunately Kalu decided to follow her advice. He picked out the biggest bone, the boar's thigh, and clenched it firmly between his jaws until it snapped. Then he started crunching on it noisily, sucking out the marrow with evident relish. The Dog watched in speechless horror.

The power in those jaws! he thought. *The sort of bone a dog would play with, a wolf can snap in two.*

'Are you travelling alone?' asked Kalu.

The Dog immediately sensed danger in the question.

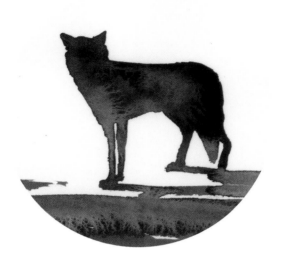

'No,' he wanted to reply. 'I have ten big friends following right behind me!' Instead he nodded, because he wasn't any good at lying.

Having eaten his fill the Dog took a long slurp from the stream that ran nearby, which had the refreshing taste of a herbal tea, infused with the many different plants that grew along its banks.

Then, with an excessive courtesy that betrayed his unease, he said, 'You have been very hospitable, but now I must continue on my way. Thank you very much for the food…'

'Don't thank us,' replied Muni, the wolf with white hairs. 'We didn't make it.'

'Well . . .' said the Dog. 'Thank you then for the very tasty water.'

'Don't thank us for that either. It was the mountain that brewed it for you.'

'In any case,' the Dog went on, slightly confused, 'I really needed it. You know, yesterday I asked an old woman for a bowl of water and she sent me off with a stick.'

'That's how it goes. Beg someone for a bowl of water and you're lucky if you get a drop. But ask for nothing and continue on the right path, sooner or later you'll come to a river.'

This wasn't at all the answer you'd expect from a forest

'You know, yesterday I asked an old woman for a bowl of water and she sent me off with a stick.'

bandit. The Dog turned one last time to examine the pack. Not one of these wolves had a collar, yet instead of seeming naked all of them looked utterly elegant, regal even in their simplicity.

'When I first set eyes on you,' said the Dog, summoning all the courage he had, 'I took you for bandits, thieves. But instead of stealing, you gave to me. Tell me, who are you really?'

'We are pilgrims. On a pilgrimage.'

That word rang a bell to the Dog. 'And how exactly does one go on a pilgrimage?'

'Simple,' replied Muni. 'You make a firm decision to go to a distant place, ideally one that's difficult to reach. Perhaps you don't even know the way. You just say, "I'm going," without asking how long it will take, or how you will return. That's not important. All that matters is that you pay close attention to everything you encounter along the way, to the landscapes you cross and the creatures you meet.'

There was a profound silence.

'In that case, maybe you could say I'm a pilgrim too,' said the Dog.

'I was sure of it,' said the old wolf. 'So why have we met here? What, may I ask, what is your destination?'

'I have to go to a place called Moon Mountain, though nobody seems to know where it is. Yesterday a friend set me on a shortcut that should have got me there by nightfall. Instead, I'm still here.'

'What are you looking for there?'

'Ah, that I can't tell you because I don't know. And even if I did I couldn't say, because as soon as you say it, it becomes a lie.'

'Ah, very good, very good...' said Muni, nodding slowly. 'It is the journey which we were all born for. But there are no shortcuts to that destination, and the way is still long. You cannot make it on your own. Come with us. As it happens, we too are going to Moon Mountain.'

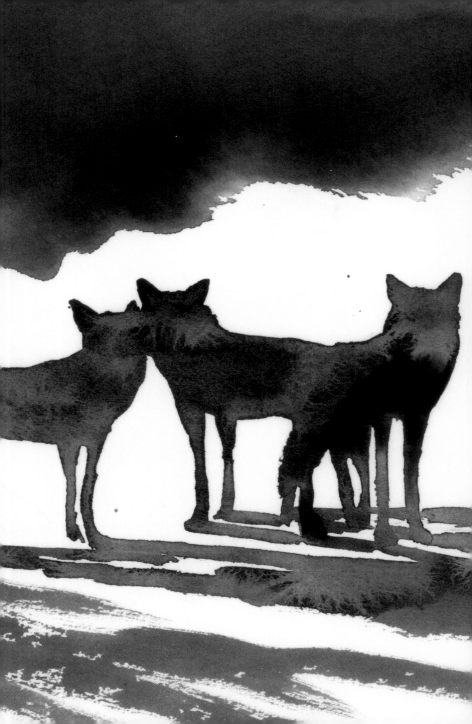

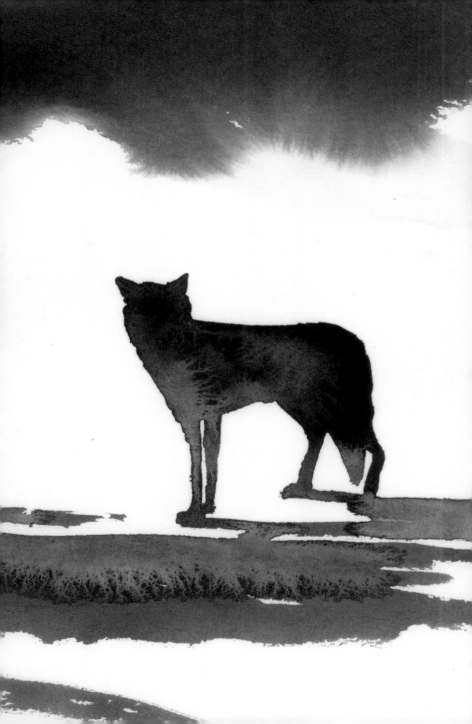

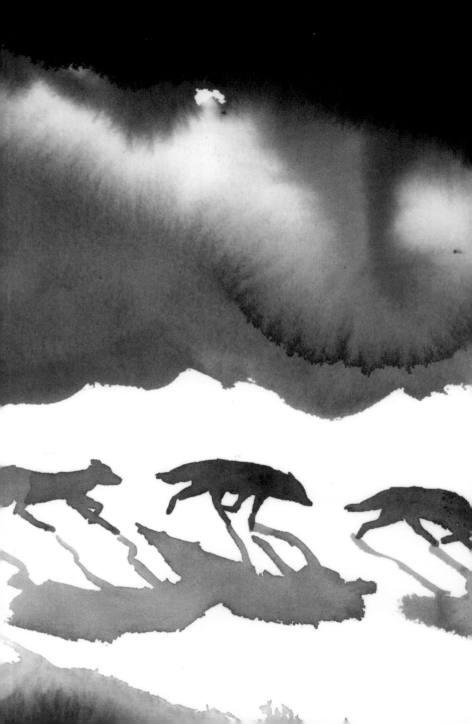

PART TWO

The Wolf

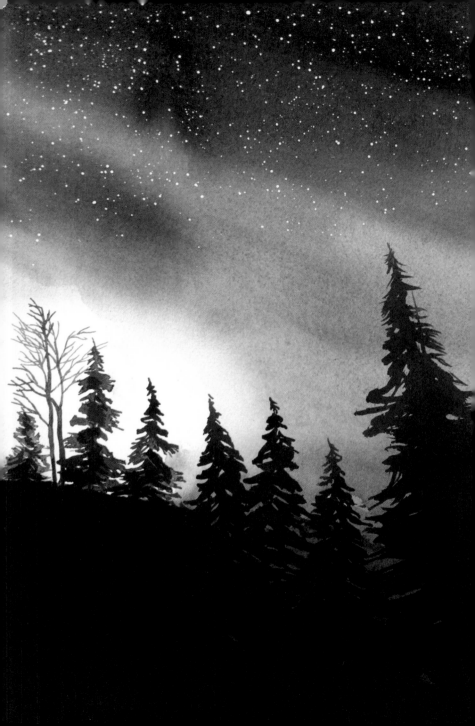

The Ancient Path

The wolves had just said they would lead the Dog when they lay down and fell asleep. The Dog was astonished. *What kind of pilgrims are these who sleep all day?*

He studied the four slumbering bodies carefully. There was Kalu, the black wolf, the strongest, who would certainly be trouble. Alina, the she-wolf, beautiful with her reddish coat, but shy. Then there was Anah, sober and disciplined as a monk. And Muni, the ancient one, whose ever-calm voice had been the first to welcome him. Though physically the weakest, it was he who seemed to be the leader of this pack. Every so often one of them would shudder in his sleep and scratch at fleas.

What an odd situation. He was right in the middle of the thing he most feared: a pack of wolves. It was incredible that their wild and ancient way of living still existed and, contemplating them, the Dog felt transported back to a

mythical past.

Now that they're asleep, I could seize the opportunity to slip away. But where to . . . ?

The Dog had just started nodding off himself when a rough paw stabbed at his ribs.

'What's happening?' he said, his eyes snapping open.

The wolves were standing all around him.

'Get up, brother, we're going!'

'Now?' he mumbled. A sombre reddish light filtered through the forest. 'But it's almost night!'

'Exactly. This is the time of the wolf.'

Without uttering another word the wolves set off in orderly single file after Muni. As the Dog didn't have the slightest intention of spending another night in the forest alone – better a pack of wolves than isolation! – he leapt to his feet and raced after them.

The wolves loped on for hours, with a long light step, without showing any sign of fatigue. Muni was a really old fellow while the Dog was in the prime of his youth, yet he struggled to keep up with him.

'Hey, wait!' he cried in alarm. 'Why did we leave the path?'

'We don't follow the human way, but the Ancient Path. The way without a way that runs through the heart of the forest, the only way that leads to Moon Mountain.'

The Dog could barely make out anything in the darkness and he kept tripping and slipping and banging his paws on the rocky ground till the pads of his feet were on fire.

'And stop panting so loudly,' growled Kalu. 'Do you want everyone to know that we're coming?'

Shortly after, there was a tiny explosion – *Pop!* – under the Dog's paw. Immediately a little bird set off startled from a nearby bush, triggering a whole flock of birds to take flight, their shrieks alarming the entire forest.

Kalu turned menacingly towards the Dog. 'Would you stop making such a racket!'

Muni stopped in his tracks and circled back. 'What was that?'

'Nothing,' said the Dog, examining a dirty paw. 'I must have trodden on a worm.'

> '*The way without a way that runs through the heart of the forest, the only way that leads to Moon Mountain.*'

'Look where you tread!' said Muni with unexpected severity. 'That's no worm, it's a caterpillar. Now, because of your carelessness, there'll be one less butterfly floating in the world!'

The Dog felt they were being horribly unfair. Not long ago they'd torn apart a boar, so he couldn't understand why they were getting all sentimental about a miserable worm? He did, though, get the point that the wolves' nature was to pay attention to every single step and slip, silent as ghosts, over the forest floor.

'I told you we shouldn't bring him with us,' hissed Kalu.

'All he does is make noise and slow us down.'

'He's a city dog,' added Anah. 'An impure one, who's eaten from human hands.'

'This journey's hard enough for us. He'll never make it.'

'He's a seeker, just like you and me,' said the ever-calm voice of Muni. 'Who knows in the end who will arrive, and who will not?'

They ran all the way through the night and as the first glow of dawn appeared, without breaking their stride the pack began climbing a slope so steep that to the Dog it

'I told you we shouldn't
bring him with us,' hissed Kalu.
'All he does is make noise
and slow us down.'

seemed quite vertical. He fell behind and it was only desperation that drove him on until, a long time after the others, the Dog too reached the top of the ridge.

The pack was sprawled on the ground, waiting for him. And dinner was ready. Far too weary even to ask how they'd obtained it, the Dog gobbled his share in silence. Then, just as the glowing rim of the sun burst over the distant horizon, the wolves prepared to sleep.

'You can rest now,' said Muni.

'Here?' answered the Dog, who could hardly imagine a more uncomfortable place. These wolves did everything

backwards! They were perched on the edge of a precipice, with a terrifying view and a bitter wind blowing. The Dog tried lying down, but of course on those jagged rocks there was no way to find a comfortable position.

'Oh, this is wonderful,' he grumbled to himself. 'Of *course* I can sleep here, buffeted about by a gale, with nothing to cover myself . . .'

'You're always thinking you have nothing, brother,' said Muni, whose ears were ever pricked. 'So you can't see what you already have. Haven't you got a lovely fur coat?'

'It's not as thick as yours and it doesn't keep me warm.'

'In front, you have a head, so clever it can guide you. Inside, you have a stomach, so spacious it can store all the supplies you need for days. Underneath, you have four paws, so strong they can take you to the ends of the earth. And behind – turn around, look, you have exactly what you're looking for!'

The Dog turned around, but saw nothing.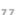

'There, behind you!'

Again the Dog turned, but saw nothing.

'You have your tail, hairy and thick. Wrap yourself in that and you'll feel how warm it is. That is the blanket you always carry with you!'

So Muni showed him the snuggly way wolves curl up, covering their muzzles with the tips of their tails, and the Dog began to understand that maybe he had a lot more resources than he'd ever realized.

CHAPTER TEN
Pilgrims

*The gang of crows flew
over the pack of wolves,
fellow travellers on
the same journey*

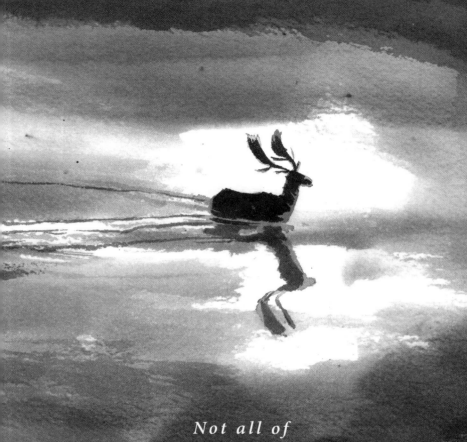

*Not all of
nature's wonders...*

...were within their reach

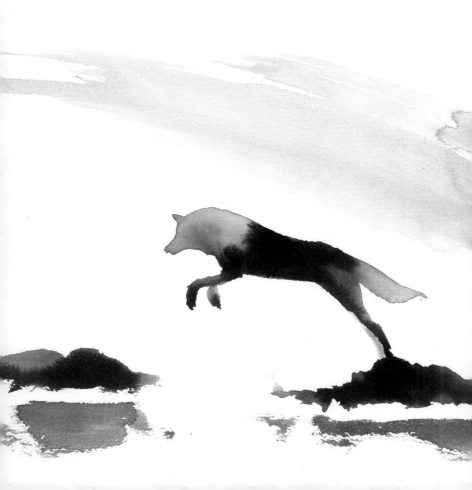

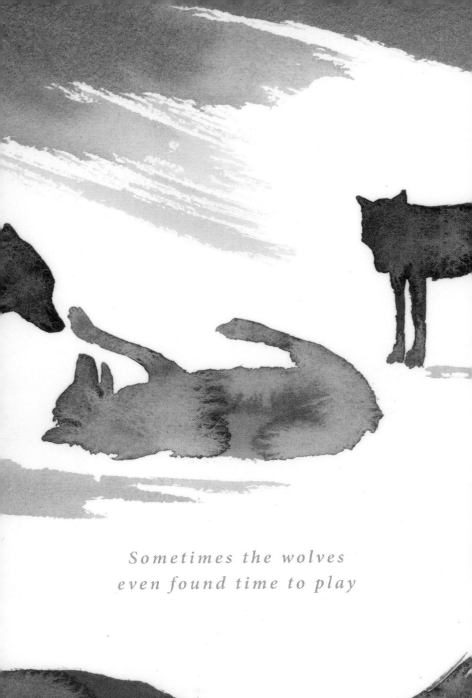

*Sometimes the wolves
even found time to play*

Closing his eyes,
the Dog sniffed
a wild presence

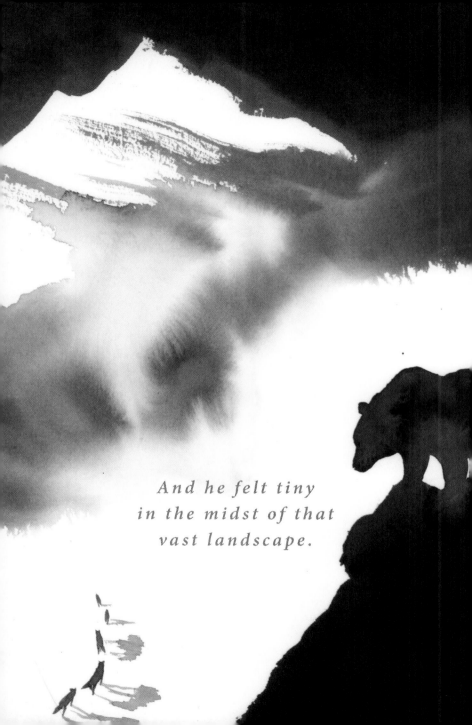

And he felt tiny
in the midst of that
vast landscape.

CHAPTER ELEVEN

Purification

So they went on, night after night after night. When it was
dark they ran through the forest; when the first rays of sun-
light appeared they hid away in the steepest and most in-
hospitable places. They contemplated a succession of land-
scapes, climbed mountains, plunged down valleys, followed
the course of rivers and crossed green woods of beech trees,
white woods of birches and sombre woods of pines.

The Dog was always last. He stumbled behind the fleet-
footed wolves and when he finally managed to catch up
with them he'd find dinner already laid out: a young deer, a
skinny hare, a pair of badgers or other tasty animals whose
names he didn't even know.

These wolves were calm, capable and perfectly in control.
There was nothing they couldn't do. Stopping to scrutinize
the wrinkles of a mountain they were able to divine where
a creek flowed. From the sudden silence of a pond of frogs,

they could locate a source of danger. And when the colours of approaching daylight inflamed the clouds and the concert of birds reached its thunderous climax, they'd already found a suitable place to lie down and sleep.

With them, everything seemed simply to appear; with them, everything seemed easy and there was nothing for the Dog to do but follow.

But the wolves were tough. They could run twenty, forty, sixty miles a night. The Dog's body was drained, his muscles cried for mercy.

One evening, when they announced that food was ready, he lost his temper.

'I'm not moving.

Leave me here. Go away!'

'No, leave me alone!' he barked, and tried to go back to sleep. The poor Dog didn't even have the strength to eat. Shortly after, a bony paw prodded him in the ribs.

'Get up, we're off.'

'I'm not moving. Leave me here. Go away!'

He didn't know how to get rid of them any more. But his protests were in vain for once they'd taken him into the pack, the wolves wouldn't let him go. Muni seized the tip of the Dog's tail between his teeth and pulled it as one pulls a blanket off a child, letting the cold wind blast him.

'Move. Do you think that by dreaming you'll get to Moon Mountain faster?'

Even when he'd got to his feet, he couldn't shake off his drowsiness or his disgruntlement. Bleary-eyed, the Dog plodded after the wolves and when they arrived at a river he was no longer amazed. He didn't ask himself where all that water was flowing down from, nor what mysterious power carried it back up. The bounty of the woods, which had once left him awestruck, had become ordinary. He'd grown accustomed to the fact that, one way or another, they always found something to drink. It splashed down waterfalls, bubbled up warm from an underground spring or lay hidden as a tasty sip in the chalice of a flower.

So what, thought the Dog, just another river. *No doubt we'll make a brief pit stop to drink, and ...* But this time he was wrong. Instead of stopping on the bank, Muni leapt head first straight into the swirling current. He was followed by intrepid Alina, then big strong Kalu and, after a moment's hesitation, Anah. When the Dog's turn came he dipped a paw in and pulled it out quicker than if he'd been bitten by a fish.

'Jump!' yelled Kalu.

'Not on your life,' answered the Dog. 'This isn't water, it's liquid ice!'

'Jump. You still stink of the City and the forest beasts can smell you a mile away!'

The wolves snickered. From the river they first challenged and encouraged him, then insulted and ridiculed him, but all to no avail. The Dog dug his heels in and refused to budge.

'Why should we bathe at night?' he retorted, venting the frustration he'd been holding in for days. 'I'm waiting for

the sun. I want to live in the daytime again!'

Muni the elder paddled towards him.

'Don't you think we love to feel the sunlight on our fur too? Every animal adores it,' he explained over the gurgle of the water. 'But in the daytime we must remain hidden.'

The Dog stared at him, tears of desperation in his eyes. 'But it's cold!'

'Of course it's cold,' replied the ever-calm voice. 'Of course at noon it would be easier. But we follow the Ancient Path and the Path comes through here and continues on the opposite shore. There's no way round. This is the

'A wolf's life is hard. Secretly, we keep an iron discipline.'

obstacle we have encountered today and we must overcome it. This is our work.'

'Work? Oh, that's a good one!' exploded the Dog. 'When have you ever worked? My Owner, now he really worked for his living. He'd leave home early every morning and come back late in the evening. Whereas you wolves, you're lazy. You haven't got a job, you don't produce anything, you don't earn anything, you just wander about the forest, stealing left and right!'

'Now hold on, brother, that's not true at all,' said Muni. 'Observe us carefully. A wolf's life is hard. Secretly, we keep an iron discipline. We live at night. We sleep on windswept mountaintops. We wash in freezing streams and,

maintaining perfect silence, we're always on the run, running further than any other animal can. This, brother, is our work. Now do your part, jump! Your body might shiver and suffer a little, but your soul will grow stronger!'

Still the Dog didn't move. 'But I can't swim!'

'Leave him,' growled Kalu impatiently. 'I always said we'd never get there with a sissy like that in tow.' He turned to the Dog. 'You can't cross a river? Fine, wait there. Sooner or later I'm sure a bear will come along and take care of you.'

A hoarse laughter rang out as the gang of crows glided effortlessly over the river and disappeared after the wolves into the forest on the other side. Finding himself suddenly alone in a labyrinth of trees, the Dog shut his eyes and threw himself into the void.

The water struck him like a slap in the face. Then the powerful arms of the current wrapped themselves around him, made him do somersaults and dragged him down. He drank, drank so much that he was close to drowning. Only a deep-seated instinct, a blind rage kept his paws spinning and somehow carried him, drenched and exhausted, to the opposite shore.

He'd done it!

After overcoming that terrible trial he realized that his whole being felt alive and tingling. As if it had been purified. As if the icy water had not only washed the stench and dirt from his coat, but had also rinsed away the weariness and resignation of his soul.

CHAPTER TWELVE

Infinity

They lie under a starry sky. They've come to a halt a little earlier tonight; the colours of dawn have not yet emerged and the crickets are chirruping still. Weary after so long a journey, the wolves have no desire to take another step and finally they rest.

The Dog smells the scent of damp earth. He can hear the tiny droplets of dew slipping down the blades of grass. He hears the wind rising towards him from the bottom of the valley, like a wave approaching. Here it is, blowing over his face, rustling the hairs of his fur, entering his nostrils in swiftly curling spirals. He drinks it in as fresh water from a stream. All around a sense of sacredness hangs, as if something, a presence, were hovering over them.

'Muni . . . Muni, what is it?'

'What?'

'What is it that makes the colours shine, that makes the

crickets sing, that makes the wind blow? That makes the stars fly in the sky?'

Another breath blows from the valley.

'What is this thing we walk and rest on, this earth? This world that we pass through?'

Five poor beggars in the middle of a forest, with nothing but their fur coats and their souls. And yet the Dog feels clearly that there's no place in the world he'd rather be than right here, right now. He likes this kind of life, it suits him: to be together, in harmony, with others, and with the

> '*What is this thing we walk and rest on, this earth? This world that we pass through?*'

universe. Wishless happy. Happy with what they have, be it little or plenty. Adventurers of the soul, alone in the night, looking out towards eternity.

'The fraternity of eternity,' murmurs Anah, as if similar thoughts were crossing his mind.

They look into the deep dark night, strewn with stardust. *What I know resembles that sky*, thinks the Dog to himself. *A handful of tiny lights in the midst of an infinite darkness.*

And suddenly he feels the Mystery penetrating him.

If the Dog had not been abandoned, maybe he would never have felt it. He would never have realized where he was. The days pass, the nights like shadows flit by, and if

now and then something unexpected didn't happen – often disguised as a misfortune – we might never realize the wonder which already is. We would not ask ourselves the greatest question of all.

What is beyond? And beyond that, and beyond, and beyond . . . ?

And suddenly the Dog's head spins and he feels himself falling, falling through the stars.

Then terror seizes his chest and he tries desperately to forget, reaches out again for something solid to hold on to. Something smaller, more familiar.

'Ooooo!'

'What happened?'

'Nothing . . .'

'Shh . . .' whispers Muni, reassuringly. 'This is the work. This is the work.'

So the Dog remains silent, marvelling at how this could have come about, this explosion of lights and sounds and smells which now surrounds him. And why? Most of all, why?

His heart tightens, his stomach feels hollow, his mind seems to have gone mad. And he wishes it would all stop, stop spinning, stop biting and hurting and confusing him so.

'Why did all this begin? Why such complexity? Why didn't it just remain still and silent and dark?'

But no answer comes. No answer comes.

Distances too vast and the sense of his own infinitesimal futility. Tonight nothing can save him. Not the hiss of the snaking river at the bottom of the valley, nor even the hoot

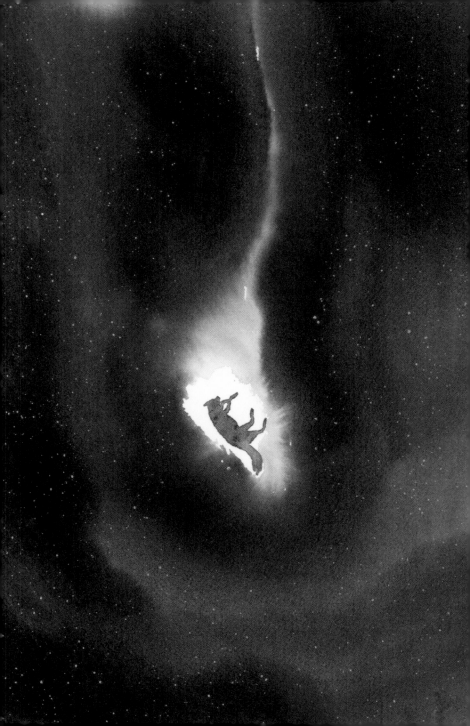

of an owl which, rather than conveying wisdom, spreads only a note of profound melancholy. The Dog, the Moon, the Owl, the River-serpent and the Dream. Here, tonight, each one alone, together, listening with wonder and all senses open to the mystery of infinity.

'What am I doing here, among a pack of wolves? Have I taken leave of my senses? I should return to the City immediately. So far we've been lucky, but this system cannot work . . .'

'Who said it doesn't work?' says Muni. 'Look . . . isn't it working?'

Still gently afraid, the Dog lets himself go, lets out the breath he's been holding, returns it to the wind and surrenders to an invisible river, which in that moment is passing by. For the space of a breath he entrusts himself to it.

The moon moves slowly in front of the stars.

'We don't know how, but it works. And it's been going for a long, long, long time. Since before wolves or dogs or trees even existed. It's *made* to work.'

All of a sudden the Dog feels something supporting him, sustaining him.

'Muni?'

'Yes?'

'Nothing.'

'Shh . . .' whispers Muni. 'Don't think about it any more. Food we have had, water flows nearby and fresh air is all around us. Once again the problem of existence has been solved.'

CHAPTER THIRTEEN

The Storm

Muni remained frozen for a long moment, his ears pricked, listening intently.

'I hear clouds coming . . .' he declared. 'And when the sheep are on the run, the wolf is surely close behind!'

A roll of thunder crashed across the sky. The trees, which until now had stood quietly in their places, started throwing themselves around, animated by a wild wind. Huge black clouds rolled over the mountaintops and descended onto the pack, which dispersed in every direction in search of a hiding place. The first big droplets of rain drummed down on their fur. When at last Alina's cry rang out, the others raced to join her in a natural cave that opened into the side of the mountain. Maybe in the past it had been the den of some bear, but now it seemed safe and abandoned. They'd barely made it inside when terrifying bolts of lightning tore through the night. The wolves huddled together in the

warm belly of the earth. From here they listened, as all the creatures of the valley were now listening, to the booming voice that echoed through every crack and crevice and cave for miles, awakening everyone.

The rain continued all night, and all day, and even the following night it did not stop. The water washed away the tracks in the ground and the scent-trails they might have followed, so leaving the cave would have simply been pointless and dangerous. The Dog began to suffer pangs of hunger. The wolves were accustomed to them.

With one swift leap
he left the cave and his dark
silhouette disappeared into
the driving rain.

'Stop whining!' said Kalu. 'We go without food all the time, for days, or a week, or more. But seeing as you can't cope, you know what, I'll pop out and pick something up for you.'

With one swift leap he left the cave and his dark silhouette disappeared into the driving rain. A short while later he was back, fur coat glistening with water, and plopped a fat toad in front of the Dog.

'Here you go, doggy. If you're so hungry, eat!'

The toad stared at the Dog with its big, moist eyes.

'Ugh, that's disgusting!' said Anah, breaking into peals

of laughter.

'If you finish it, there are plenty more where that came from,' said Kalu. 'And snails too!'

'Well,' said Muni, turning to the Dog. 'Are you going to eat it or not? Or should we ask Kalu to take it back outside where it was probably enjoying itself? You know, these fellows love a good storm.'

The Dog slunk into a corner of the cave and didn't reply. 'Everything has its reason for being,' continued Muni. 'We're always on the move, but once in a while it's good to be forced to stop and take some time for contemplation. Now's the perfect opportunity. We've even been lucky enough to find this ideal resting place today. Therefore, I say, why not declare a day of fasting? Then the other creatures can take some time off too, without worrying about wolves, and enjoy this impressive celestial show.'

The rain wet the heads of the mountains, it washed the trees, one by one, and every blade of grass. It showered the animals, wiped the odours off the paths, refreshed the earth and bestowed new life on the moss that grew in places it had not penetrated for months. It fell in long grey lines. Trillions of drops broke over the rocks or dived with a round, hollow sound into the puddles that were forming everywhere. They infiltrated the cave, soaking the paws of the wolves, turning the air sour with the smell of wet fur.

They waited. Now and then one of them got up to stretch, then curled back up into a ball and dozed off again. The wolves were silent creatures by nature, but also curious and intelligent. To while away the time they turned to the Dog.

'What was it like, brother, living among the humans?'

Thinking back to the Owner he'd lost, tears welled up in the Dog's eyes. He didn't cry for himself anymore, but for the Owner who would no longer have anyone to confide in when, tired and frustrated, he came home from work. The Dog spoke of the human with such profound devotion that Muni gazed at him in wonder.

'You've no idea how good humans are!' continued the Dog. 'My Owner, he'd brush my fur every day and tickle me behind the ears and hug me tight, as if I were his son. He needed me, and I needed him. When he went to sleep I'd lie

> *'My Owner, he'd brush my fur every day and tickle me behind the ears and hug me tight, as if I were his son.'*

down at the foot of his bed and—'

But he never got to the end of his sentence because the wolves had broken out in howls of laughter.

'That's the best one I ever heard!'

'He slept with the human, he did!'

'Hmm,' the Dog cleared his throat, with a touch of embarrassment. 'I've noticed you stay away from them – you won't even walk on their paths. Why?'

'The humans almost exterminated our species. They massacred us by the thousands. Once we wolves were many, we walked the whole earth. Now they've snatched

the most fertile lands for themselves and, as if that weren't enough, they've even seized the daytime, forcing us to slink around furtively at night.'

'Nonsense!' said the Dog in disbelief. 'I know them a whole lot better than you do and I know that humans are kind and generous, and we're their best friends.'

'Oh yes, the dog is a man's best friend, but the wolf is his worst enemy,' replied Anah. 'Though in truth, we're the same animal.'

'A *friend* of man?' butted in Kalu furiously. 'Absolutely, as long as we do exactly as he commands, as long as we're his servant. Humans would like to tame every other living creature and impose on them their own invented laws – which are the laws of the City, not those of the universe. They expect us to lick their feet and worship them as gods.'

'They shall never be my gods!' hissed Alina.

'Whoever obeys and defends them will be rewarded.'

'Traitors!' yelled Anah.

'But whoever refuses them will be beaten and killed. They want a trusty companion who doesn't know how to say "No".'

'You don't have a very high opinion of dogs, do you, Kalu? You see us as the sellouts,' said the Dog. 'The weak cousins who surrendered, who couldn't handle the pure life in the wild. You think we bowed down to the humans in exchange for our daily meal.'

'We shall maintain our independence,' continued Kalu. 'We reject their gifts and stay away from their easy temptations. We prefer challenges and uncertainty to their comfortable living. Between two paths we choose the one

that goes uphill. Between two resting places we choose the highest and rockiest, which we'll share with spiders and scorpions. Between day and night, we choose the night. And between two companions, we choose solitude!' He took a breath. 'We're not afraid to face the most dangerous animals, those who defend themselves with talons and horns, and we leave to the humans the sheep and the chickens – those stupid birds that can't even fly!'

Kalu's eyes shone like two fires.

'Oh, they may break me, but they shall never bend me!

In that moment a clap of thunder rang out that was so loud it echoed through the entire valley.

And even if no animal likes us, all of them respect us. Because they know that we still walk the Ancient Path and preserve the eternal truths, which are as ancient as the hills.'

A deep silence fell over the cave. Then, over the constant drip-drip-drip of the rain, Muni's quiet voice arose.

'It's not that we don't want to be friends with humans,' he said. 'It would be wonderful. But we must remain free, independent, to follow the instincts we ourselves were born with, not theirs. Humans see themselves as the owners, the owners of the world. But they're not, not yet. We continue

to survive in the shadows, where they have not yet reached.'

'It isn't easy, though,' observed the Dog gloomily, gazing out at the sheets of rain that seemed like they would fall forever.

'It's never easy to be free. But it's possible. Even you, brother, should know that you do not need an owner, a master. Be the master of your own self!'

In that moment a clap of thunder rang out that was so loud it echoed through the entire valley. Like a retreating armada, the clouds flew off and the rain ceased.

The animals had fasted and as they stepped out of the cave each one of them was hungry, hungry as a wolf, wondering where their next meal would come from.

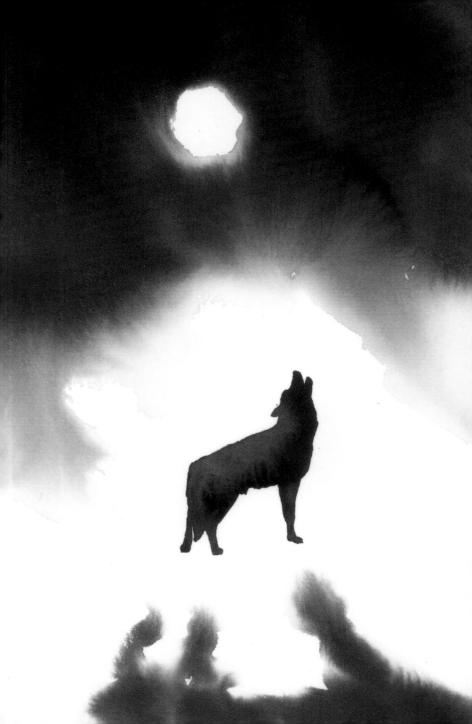

The Feast of the Sky

Outside the cave, over a vast mountain prairie, the mists were rising like ghosts towards the sky. Just as the wolves set off at a brisk pace to warm their damp bodies, they stumbled upon a spine-chilling sight. In the middle of the soft grass, around a great standing rock, lay an entire herd of cows. Dead.

Suspecting a trap, they sniffed the air for clues. But the smell was good, the bodies still warm.

'Poor, poor, innocent creatures!' It was Muni who broke the silence. His gaze had risen from the horrifying scene to follow the elongated shape of the boulder that pointed tellingly towards the sky. 'The very rock where they sought shelter during the storm attracted the lightning . . .'

The Dog recognized at once that laid out before them was a dinner of dizzying proportions.

'This gift is not intended for us alone,' said Muni solemnly.

'We must give thanks and prepare a banquet.'

He gave the wolves instructions to tear open the cows, strictly cautioning them however not to eat a single bite. The Dog watched with rapt attention as the wolves dragged the carcasses into an orderly line, then opened them up, one after the other, from the soft spot in the middle of the belly. They went about their business like professionals, every gesture precise and elegant. They knew what they were doing.

When everything was ready, Muni made an inspection.

They went about their business like professionals, every gesture precise and elegant.

Satisfied, he looked up towards the firmament, so pure and bright that you could almost hear the stars twinkling. Then suddenly it began.

'Ooooo-ooooo-ooooo . . .'

From the very first note the Dog was mesmerized. Never in his life had he heard a tune at once so triumphant and so sad. Muni's voice was joined by Kalu's, then Alina's, Anah's, and one voice blended into another in a perfect chorus. So beautiful was the Song that the whole prairie, which after the storm had resumed its ruckus, fell silent. Even the crickets, master musicians of the night, let their own trilling subside to listen to that melancholy call, profounder

even than their own. The Dog's hairs bristled on the back of his neck. Though he couldn't understand the words, he had the distinct impression that he recognized the Song, an ancient melody that told of other worlds, beyond the living and the dead. It was the most sublime expression of Truth he'd ever heard.

'Ooooo-ooooo-ooooo-ooooo . . .'

Each wolf sang alone, like a king or a queen, looking out into the vastness of space, and an irrepressible urge rose in the Dog to form the same vibrations. But in his own throat those noble notes choked into the ugly croak of a toad.

As if that song of devotion, which came from a universal state of mind, had dissolved all fear, a multitude of animals began to emerge from every corner of the prairie. Foxes and badgers, squirrels and a family of wild boar – mother boar watching carefully over her little ones. At the edge of the prairie, where the woods began, even the silhouettes of deer, usually so vigilant and fleeting, appeared.

'Welcome all,' proclaimed Muni. 'Welcome to the Feast of the Sky!'

The gang of black crows swooped down and hopped happily towards the party. Three hawks arrived too, and a cloud of flies. From hidden holes in the earth emerged moles and mice, beetles with iridescent armour, pale worms and armies of black ants and red ants. Finally, with a great beating of wings, a golden eagle alighted and perched herself on the biggest carcass.

The Dog stared wide-eyed at the scene – until he remembered that wild animals don't like being stared at at all. So he pretended to avert his gaze, while continuing to

look out of the corner of his eye. Because as special as it was to be part of a pack of wolves, it was even more extraordinary to share a moment with so many different species.

Big and small, friends and enemies, gathered beside one another and ate to their heart's content. There was plenty for everybody, so there was no need for the usual pushing and shoving, threatening and competing. Each animal could select their very favourite morsel, which for some was a tender thigh, for others a warm liver or an ear. The crows liked to begin with eyeballs and tongues, the worms with intestines, while the wolves themselves, who after all had prepared the feast, waited politely until all the others were satisfied, and helped themselves last.

'And now, off we go again,' said Muni abruptly, as the Dog and the wolves were still gnawing away.

As a sign of gratitude to these beings that they feared, but rarely saw or heard, the guests bowed to the departing wolves. The Dog looked around, perplexed that they were forgoing such abundant left-overs.

'Shouldn't we stay and finish the feast? There's enough food here for days!'

But Muni was already loping away. 'Leave it for the other creatures – they haven't got jobs either!' he said with a smile. 'As for us, it's better not to stay more than three nights in one place. A home that's too comfortable will tie you down. But we are pilgrims, heading to Moon Mountain, are we not? Whatever we need along the way, we'll find along the way. All we must do is keep running.'

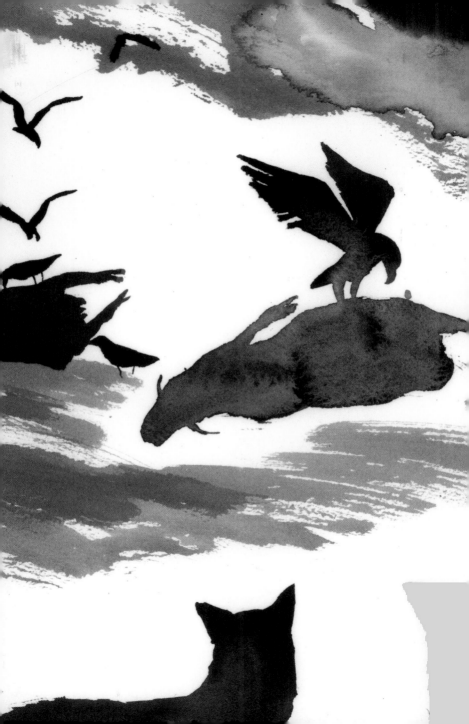

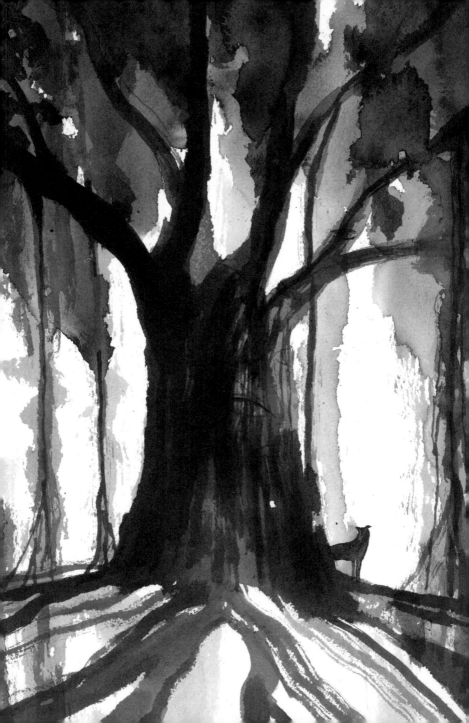

The Giant

After the great storm, after the night of thanksgiving and the feast with all those creatures who got along so wonderfully, after even that gesture of respect which the other guests had made to the departing wolves, the Dog felt more miserable than ever. It had been that very sequence of extraordinary events that had made him feel he was not one of them, and never would be.

'I am not like you,' said the Dog to Muni. 'You are all silent and strong, good at everything, elegant in every gesture, able to find food not only for yourselves but for others too. You are respected by all creatures and know the forest as if it were your home . . .'

'Brother, you will soon come to know it too.'

'And why do you always call me "brother"?' retorted the Dog angrily. 'I am a dog, you are wolves. My eyes are grey, yours are golden. The bones I chew on playfully, your jaws

can snap in two. Your fur is thicker than mine, you never feel the cold, your paws are nimbler and when you, Muni, who are so old you could be my grandfather, set off at a fast trot, I can't keep up. And above all . . .' He was barely able to continue his sentence. 'Above all, you know how to sing the Song. The Song, which is the most sublime vibration I've ever heard, yet when I tried to emulate it, it got stuck in my throat.'

'The Song is not something you form with your lips or in your throat. It's something that forms by itself, first in your mind, you see . . .'

> *'No, I don't see, for*
> *I am just a stupid dog;*
> *the most I can do is bark.'*

'No, I don't see, for I am just a stupid dog; the most I can do is bark. I cannot follow you any more. I am not one of you!'

Muni understood his sadness, but had no idea how to console him.

'Today we shall not run far,' he said at last. 'We'll take a little detour. I know a giant who lives around here. I think we should pay him a visit.'

Solitary and immense, the Giant lived on top of a hill. He had many arms and, set among the wrinkles of his hardened skin, many eyes with closed lids, and long tresses of greenish hair that hung to the ground and swayed gently in

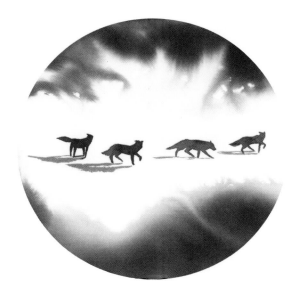

the breeze. His trunk, though, remained always perfectly erect and immobile, like a great being lost in centuries of meditation.

His whole being emanated serenity. When the pack approached him, the heat of the afternoon quickly vanished and, as if caught in a delicate spell, the wolves plunged into the fresh blue lake of his shadow. They lay down between the muscles of his roots, their eyelids became heavy and sleep overcame them. Beneath the Giant it was easy to forget where one was going, and to desire nothing more than to remain there forever.

Looking up, the Dog, who could not sleep, realized that many creatures had already made their home there. It seemed like a huge block of flats crawling with tenants

that constantly came and went, each according to their own schedule.

He saw a little lizard ascending, a spider descending on the escalator of his threads, a column of marching ants, two squirrel couples, at least thirteen different species of birds, a congregation of butterflies and a thin green snake coiled around a branch. Normally these disparate creatures would have chased and stung and bitten and chewed each other. But, while in the outside world the ancient game of cat and mouse raged, here under the shadow of this majestic Giant a single mood prevailed: peace.

Embraced by his long tresses it was impossible not to feel completely safe and the wolves, bursting at the seams after the great feast, slept for the rest of the day. The Dog, on the other hand, turned over and over in his head the thoughts of his own inadequacy, and could find no solution. Having already once addressed the Unmentionable, that probably doesn't even exist, why not also try talking to a tree?

'They say you bring peace, yet my heart remains troubled,' he said, turning towards the Giant. 'I run with the wolves now, but compared to them I am stupid and incapable. I notice constantly how clever they are, and how fast, and how sharp their fangs are that they use to hunt. Is this the key to life, then, that you have to be strong? How do you do it – what is the secret to *your* survival?'

He waited for a very long time. The sun completed its journey across the sky and the moon chased it, while the wolves continued to sleep. At the first hint of dawn a slight breeze trembled through the leaves and, with a soft and tender voice quite unexpected for a giant, the tree replied.

'In that case I am far stupider and more incapable than you!' It almost sounded as though he was laughing. 'I have no teeth to sink into prey, no running abilities to speak of – I can't take even a single step! If there's something I like, I cannot chase it. If I am attacked, I cannot run away. I have no defences, I have no thorns or claws or poison with which to fight. And yet here I am. I have lived long, so very long. I am, in fact, the most ancient creature in the forest.'

'But how do you do it, when you're so tall and mighty? What do you eat to nourish this huge body? Who looks

I am always between two worlds, half awake and half asleep,' rustled the Giant delicately.

after you? Who feeds you every morning when you wake up?'

'I don't really wake up in the morning, nor do I fall asleep at night. I am always between two worlds, half awake and half asleep,' rustled the Giant delicately. 'Every day, though, at dawn, when the red sun appears far away on the horizon, I feel something stir inside me. Then my leaves straighten and an energy flows along my arms and through my trunk, all the way down to the tips of my feet which are underground – unless it's my mind that is under the ground and my feet that reach up to the sky, as I sometimes think.

In such moments I feel revived, as if the sun himself is sending me food.'

'And what then do you do for drink? You too must get thirsty sometimes.'

'Yes, I too get thirsty. There's a river down there, you can see it from the tips of my foliage, and often I hear the gurgle of its water. But though it's not far, I cannot reach it. The animals that live with me go to it often, while I stay here and wait. I have learned not to desire what I don't have and to welcome everything that comes to me. Sooner or later everything comes. I imagine that my way of being must be pleasing to someone, maybe to the little creatures who take me for their home and live among my arms. Maybe they put in a good word for me. Because once in a while, from

far away in the north' – at this, one of his branches leaning in that direction quivered – 'in a place they call Moon Mountain, a little cloud forms and flies all the way over here, right above my head, and brings me water. And I am grateful.'

The Dog was amazed by the idea of such a strange thing happening.

'So there's no need to be as strong as Kalu, as fast as Alina, as serious as Anah or as knowledgable as Muni?' he observed. 'What is *your* skill, then?'

'Trust is the most powerful tool of all. Whoever has trust reaches their goal immediately,'

'Trust is the most powerful tool of all. Whoever has trust reaches their goal immediately,' whispered the Giant. 'See how many different ways there are to be in the world. You too, if you trust, will reach your destination.'

The Dog found courage in these words. Because if even a being that was utterly harmless and immobile managed to survive, maybe he too, who was just a stupid dog, would find his way of going through this life.

CHAPTER SIXTEEN

The Art of
the Hunt

Something was burning through the darkness, not in the sky but on Earth. It looked like a heap of stars that had fallen on the distant plain. It was a city.

As it lay in their path, Kalu believed they should cross it. Muni was absolutely opposed. It represented simply too great a danger and they would have to circumvent it.

A danger? Thought the Dog, feeling instead a pang of longing. To him those glimmering lights were a reminder of all the magic and merriment that humans were capable of.

The pack was racing through a side valley, following the course of a river, when Muni stopped short. One of his ears flicked to the left, tracking some signal. Every muscle of his body was alert.

The Dog couldn't hear anything except the squawking of crows overhead, which he'd become accustomed to.

'We've got to cut up the ravine.'

'No, Muni,' said Alina. 'It's easier to stay low and go around the mountain.'

Again the squawking sounds rang out; again Muni's ear twitched in their direction.

'Odin says: climb,' insisted Muni.

'*Who* says?' asked the Dog.

'Odin, the leader of the crows.'

'They've even got a chief, have they?' asked the Dog sceptically. 'And I always thought those ugly birds were all the same.'

'If you don't bother to look carefully, that's how it might seem. But in truth every animal is different; each crow has a distinct personality. And Odin in particular, with his one blind eye, is an extraordinary character indeed.'

Muni began the ascent while the others reluctantly panted after him.

'Your eyes are young, while mine are fading,' said Muni upon reaching the mountaintop. 'Tell me, what do you see down there?'

'Another set of hills,' said the Dog, surveying the scene. 'With a river of milk flowing through them. At least that's what it looks like, in the moonlight.'

'And that, indeed, is what is it,' said Muni. 'For what is milk but the finest nectar which a mother makes to feed all her children? And do you see nothing else?'

'No, no … Oh, wait a moment!'

A movement had caught his eye.

'I don't believe it … The strangest thing – a great beast with many heads! It's there, look, silhouetted against the

shimmering reflections of the river.'

'I cannot see so far, but I know it well. And tell me, are some heads drinking while others are watching, always on the lookout?'

'Yes, that's exactly how it is, Muni!'

'That's why it's so hard to catch.'

'I would never have believed a many-headed creature ...' said the Dog in wonder.

'It is not one, it is a herd. Deer, probably.'

'But how did you know they'd be there, Muni?' asked the

'How graceful they are!'

exclaimed the Dog, starting to

discern the separate animals.

Dog. 'You saw through the mountain!'

Muni didn't answer. 'So tell me, what are their horns like – wide and flat, or thin like the branches of a tree?'

'Wide, I think.'

'Fallow deer then. Less fierce, more fast.'

'How graceful they are!' exclaimed the Dog, starting to discern the separate animals.

'Oh, they're pretty all right,' said Kalu, 'but not too bright. Run first, then think, that's their way. They'll run from anything. I once saw a dozen of them fleeing from a bush swaying in the breeze!'

The wolves laughed heartily.

'Shh!' hissed Muni. 'The time has come, brother, for you to learn the art.' He addressed the Dog solemnly. 'Slip down that slope, swim across the river – you know how now – then appear suddenly on the opposite bank and make the most blood-curdling growl you can. They'll panic, and we'll be waiting for them over there.' His nose pointed towards a large pile of rocks.

'You're not planning to harm those creatures, are you?' asked the Dog in horror.

'All right, Alina, you go,' said Muni, without wasting an

Soon afterwards a young deer spotted a terrifying muzzle with bared teeth on the opposite bank.

instant.

Silent as a shadow, the she-wolf, the fastest of the pack, melted into the night.

Soon afterwards a young deer spotted a terrifying muzzle with bared teeth on the opposite bank. He bolted without a moment's thought, and thoughtlessly the rest of the herd went after him, running straight towards the rocks where the wolves were lying in ambush. Muni lunged first, but he wasn't as nimble as he'd once been and the deer dodged him easily and vanished. Kalu, with his usual swagger, went after the largest beast, the one that – judging by his

crown of horns – was the leader of the pack. He stayed hot on his heels for a while, but in the end couldn't run any further and he had to let him go. Meanwhile the rest of the herd had dispersed and anyway, once the surprise factor is lost, it's futile trying to keep up with deer.

Only one young female, with an elegant brown coat flecked with white spots, had remained. Why she hadn't escaped was a mystery. She simply stayed there, watching. Alina quietly attempted a surprise attack from behind, but with three nimble leaps the doe stayed out of reach. Again the doe stopped and gazed at the wolves with big, tender eyes.

Anah tried pouncing on her from the side, but another push from her long slender legs and the doe sailed right over a thorn bush, remaining suspended for a moment high in the air. She seemed to be playing with her predators, who chased her this way and that. Sometimes she let them get close, before suddenly accelerating and leaping over their heads. Her every move was so graceful, crisp and light, that the Dog felt giddy, as if he were falling in love. He wished that no wolf, ever, would be able to reach her. And soon after, in fact, with their tongues lolling out of their jaws, the wolves surrendered. She'd won.

It was then that something totally unexpected happened. With a leisurely step the doe headed straight towards the Dog. Their noses were about to touch when she did a swift skip to the left, a skip to the right, planted her rear hooves firmly into the earth to leap away . . . But she never made it.

Seeing that deer leg fly by, the Dog, possessed by a deep primeval instinct, whirled around and sank his jaws in. A

hoof struck him on the nose. Searing pain. But he didn't let go. The weight of the animal crashed onto him. As the doe rolled and kicked on the ground, Kalu's black shadow fell over her. His jaws clamped around her delicate neck. In the wolf's eyes blazed neither anger nor pity, but absolute determination. The doe fell still, as if she'd fallen asleep.

Only then did the Dog awaken from his trance and he found himself before a defenceless creature. Her big eyes, still wide open, stared at him with infinite tenderness. The hunt was over.

'Congratulations!' said Kalu to the Dog, still panting. There was a new note of respect in his voice. 'This one is yours.'

The Dog didn't move. *Mine? This doe that doesn't even*

have horns, this creature who's never harmed a thing and fed only on the fresh grass that grows in the woods . . . ?

'Go on, do the honours. What are you waiting for?' said Kalu.

The gang of crows, which had earlier been circling above, dropped into a nearby tree, awaiting their share. The Dog shuddered. Maybe because he'd never really wanted to know, he'd never asked how the wolves got their food.

'Now I see who you really are!' he blurted out in unexpected rage. 'Exactly what I thought when I first met

> '*Exactly what I thought when I first met you: you're not pilgrims, you're bandits. Assassins!*'

you: you're not pilgrims, you're bandits. Assassins!'

'But we only took one deer. The rest of the herd runs free.'

'I thought all things came to you. But if *this* is how things are, you can count me out. This life is not for me. I'm done with you, I'm going back to the humans!'

'Do as you please,' said Muni angrily.

Without according him even one more glance, wolves and crows pounced on the fresh corpse splayed out on the ground, while the Dog turned and ran as fast as he could towards the big city that glowed so warmly in the distance.

PART THREE

God

CHAPTER SEVENTEEN

Return to the City

The forest thinned out and turned into an expanse of fields. Through the fields snaked narrow paths which led to a dirt road, which led to a black road, which led to a long straight highway which led to the City, which was just awakening. Even if it wasn't *his* city, the Dog felt he was heading home. There was something familiar about that smooth pavement, which seemed soft and welcoming to his paws after weeks in the forest.

The crooked lines became straight; the wrinkled tree trunks became lamp posts, each one exactly like the other. The grass and the flowers and the butterflies disappeared. Somewhere the sun was just rising, but no one paid any attention to it.

There weren't many cars about yet, but the Dog was overtaken by two massive trucks, packed full of pigs, whose beady black eyes stared out between the metal bars

containing them. In that fleeting glance the Dog caught a sense of desolation and despair. 'I wonder where they're all going? They don't look like pilgrims.'

During his time with the wolves the Dog had learned to make himself almost invisible so he proceeded, unnoticed, towards the centre of the City. He didn't have a plan, but having developed a bit of trust in the notion that things have their own way of working out, he pushed on, simply curious to see what would happen. Because something always happens, doesn't it?

Looking around, he noticed how on the pavements nothing grew. When he reached the main square he found himself a shadowy corner and there he stopped, to watch without being seen. The fragrance of freshly baked bread wafted out of a storefront. Necklaces of sausages hung behind another. But woe betide if you tried to enter! The Dog knew these shops were for humans only.

He would have to find himself a new owner, that much was clear.

Carefully he observed each passer-by, trying to discern which one might want to adopt him. A homeless drunk staggered by, recovering from the binge of the previous night. Then a well-dressed businessman with his briefcase – *clic-clic-clic* went his shoes – but his brisk pace indicated that he had no time to lose. A group of schoolchildren raced by with their backpacks, late for school. The Dog would have liked to play with them, but unfortunately they were alarmed by the sight of him and fled. A young woman stepped out of a parked car, her high heels indicating she wanted to be taller than she was. A scent so powerful

enveloped her, like hundreds of crazed flowers, that it stung the Dog's nostrils – even the bees probably wouldn't have appreciated it. She was wearing a red dress and three collars around her neck. Her lips and her fingernails were red, too, as if she'd just attacked some prey.

The Dog stood still as a statue, watching, listening, sniffing the air. Many people walked by, but none was to his liking. Suddenly these humans seemed totally bizarre to him, so different from the creatures he'd met in the forest. Not one of them, for instance, was naked. They all covered their natural skin with some sort of cloth, wore shoes on

> *He would have to find himself a new owner, that much was clear.*

their feet and all carried at least one extra object: a hat, a bag, a stick, an umbrella, a briefcase ... The Dog felt a stirring of pride for being complete just as he was, sufficient unto himself, like Muni.

He closed his eyes and listened deeply to the throb of the City's heart, made up of the rumble of engines, the footsteps on the tarmac, the constant opening and closing of doors, the sirens and the incessant chirping of telephones. There was something not quite right about it: it was too over-excited, too merry. It was different from the beat of nature. It pulsed ceaselessly in the background and all the humans, without realizing it, marched to that rhythm. Those

humans had once seemed to him like gods. No more.

At the opposite end of the square a musician with his dog – a female, the Dog noted – tossed a blanket onto the ground and sat down to strum his mandolin. He played a pleasant song, which nobody listened to, though occasionally someone tossed him a coin.

The Dog walked up to them proudly, chin up, tail held high, and immediately caught the attention of both the she-dog and the musician, who turned to the Dog and started improvising:

> *O noble stranger so lovely and sleek*
> *Why do you come to us, what do you seek?*

> *Of dog or of wolf are you a cub?*
> *What does it matter, you just need some grub!*

> *If you delight in our little song*
> *Gladly your owner I'll be before long*

> *My clothes are in tatters, my song's outta tune*
> *But follow us and you'll have biscuits by noon!*

When the musician and his dog got up, the Dog followed them.

He followed them up many stairs, through a creaky doorway and into a tiny apartment that smelled stuffy. Only one room and a kitchen. On the balcony stood a few plants, so cramped in their pots that it made the Dog smile. Down below were a few trees, their foliage trimmed to look

all neat and regular. Even they had been tamed.

Life here would certainly be easy. There were no dangers. No risk of sitting on an irate scorpion, no need to curl up in his tail to keep warm. In the apartment it was neither hot nor cold, not a breath of wind blew. There wasn't much to look at either, other than the shadows of birds flitting past the closed window. So, after sniffing around a bit, there was nothing left for the Dog to do but fall asleep on the carpet.

The only excitement of the day was the musician's return in the evening. Even before he set foot on the stairs the she-dog recognized his gait approaching and rushed to the door, wagging her tail. Remembering his duties, the Dog also got up quickly to greet him, just as he had done with his previous Owner.

'Come! Sit! Paw!' said the musician.

The Dog performed each command perfectly and the musician was happy.

'You're a good dog!'

And you're a good man, thought the Dog. *You're easily satisfied.*

After dinner the musician tied a rope around the Dog's neck and took his pets out for a walk. 'Tomorrow I'll buy you a real collar!'

They shuffled slowly along the pavement, trying to stop at every patch of grass. Only here could the Dog catch a whiff of the earth. Otherwise one street was like another, covered in a hard, smooth layer of black. But by now the Dog knew that beneath the tarmac of the City, beneath the concrete houses and the high-rise buildings, there was something else, huge and mysterious and still very much

alive. And it was calling him.

Cars zoomed by leaving behind stinking trails of smoke, which lingered over the City like a bad omen. An anxiety he couldn't understand gripped the Dog. In his dreams he kept seeing the wolves, who lived in harmony and passed through the world hardly leaving a trace. Except for the Song, the Song, which he couldn't get out of his head . . .

Back at home, the musician would mostly sit staring at a screen over which many colours paraded. The Dog realized he didn't have much to learn from him. He knew this life already. After the vast open spaces he'd crossed it wasn't easy to go back to walkies on a leash, or sleeping every night cooped up in an apartment.

On the third morning, as he was about to eat his biscuits, the Dog became thoughtful.

'This food he gives us every day, where does it come from?' he asked, turning to the she-dog beside him.

'Don't ask.'

'But I *want* to know.'

'From the pigs.'

'Pigs? And how do they end up in here?'

'There's a house, hidden on the outskirts of the City, where they're brought in by big trucks. They go in alive and come out dead. I saw it once.'

'And how do they die, the pigs?'

'The humans kill them.'

'The humans?'

'Of course.'

The Dog had only seen humans pulling food from the fridge, or walking out of supermarkets with their bags full

of it. He'd never asked himself where it had come from originally.

'Ah, so that's the truth,' said the Dog, recognizing it at once. 'They kill too, but out of sight, secretly. All right, if that's the way it is and there's no way to avoid it, I shall learn to do as the wolves do. From now on, I'll only eat food I have the courage to catch myself.'

He left his bowl of dog biscuits untouched.

'Aren't you having those?' asked the she-dog.

'No,' replied the Dog. 'Today I won't eat.'

Around noon the musician returned home after a morning spent strumming his mandolin on the streets. His pockets jingled with coins and his hands held a bright new collar for the Dog. He turned the key in the lock, pushed open the door ... but in that instant the Dog, who'd been waiting for him, slipped through his legs and raced down the stairs.

'Hey, where are you going?' called the musician. 'Come back!'

'No. You come with me, if you like!' barked the Dog. 'But I must keep going to Moon Mountain!'

Maybe the musician understood, but he didn't budge. So the Dog ran down to the street and then just kept on running till he'd left the City behind him and the earth became soft under his feet and the metal poles turned back into trees.

And they never saw him again.

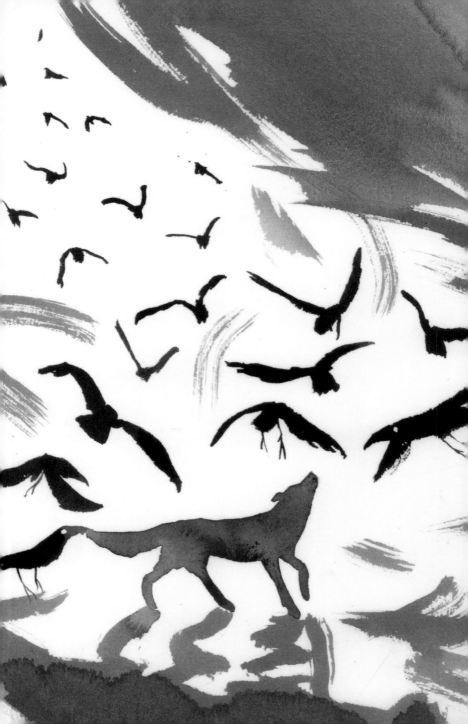

CHAPTER EIGHTEEN

When the Earth Shakes

The Dog didn't know if he would ever find the wolves again, or the Ancient Path, but he continued along his way without too many worries, fairly certain by now that if he just kept going, sooner or later something would happen. It wasn't long before he heard an ugly squawking which he recognized at once. Odin and his black gang were swooping above him in the air, turning loops, flying belly-upwards and generally doing the most extraordinary acrobatic feats. After circling a few more times – almost as if to show him the meaning of freedom – they headed straight as the crow flies towards the distant hills, where they disappeared into the yellow flame of an autumn tree.

The Dog headed that way too, lost in thought. *I can't keep following the wolves, being protected by them, living in the shadow of their knowledge, sleeping where they choose, eating what they catch. That's all very well at the start, for a*

new, inexperienced member of the pack, but after a while, Kalu's right – I become a drag. With me in tow, always slow, always doubtful, they'll never reach their destination.

He decided that if he wanted to stay with them he'd have to start giving something back. He had to become a wolf. But this seemed like an impossible transformation. How could he, a city dog, ever become so resolute and responsible? His whole life he'd been used to receiving hand-outs and cuddles. Sure, he barked, but only from the safety of his house! Nothing had ever been asked of him except to be obedient, wag his tail, agree to whatever stroll was proposed and bring a little cheer to his Owner. Never could he become as regal as a wolf.

Seen from up here, the City below looked increasingly like an anthill. And the Dog suddenly felt like someone who's spent his whole life with his head stuck inside the anthill, believing that the world was ruled by ants. No, no, no, there was a life far greater than that of the humans! It was below and above and all around the City. It was everywhere, when you learned to see it. But holed up in their fortresses, the humans usually managed not to notice it at all.

By the time he reached the yellow tree, the crows were already gone. In the muddy earth beneath it, though, he discovered the fresh footprints of a wolf. One wolf. Where had the others disappeared to? At first he followed the tracks with his nose, then he tried putting his own paws exactly

where the wolf had put them and, to his surprise, very soon he felt himself falling into a rhythm that pulled him effortlessly forwards. He leapt over a fallen tree, bounded swiftly around a lake … and then, there they were! Not one but all four of his fellow pilgrims, loping behind Muni in such perfect single file that they left behind only one set of prints.

By following precisely in their footsteps the Dog had finally learned the secret of their stride. He caught up with them in a flash and there was lots of joyful tail-wagging all around.

By following precisely in their footsteps the Dog had finally learned the secret of their stride.

'I knew you would return!' said Muni.

The Dog drew alongside Kalu and as they ran their noses brushed each other lightly.

'Good dog!' said Kalu. 'But how did you manage to find us?'

'I followed your followers, the crows!'

'Ah, not so stupid, not so stupid after all, brother!'

'Ooooo-ooooo-ooooo …' replied the Dog, and this time it flowed easily from deep inside him, and the other wolves immediately picked up the Song.

They'd just reached the top of a ridge, and they threw

themselves headlong down the other side, all of them together, like a flock of birds carried by a wind current, like fish tumbled in a mountain torrent. The world blurred around them and the path drummed under the fierce rhythm of their paws.

Fully awake, ecstatic, the Dog let life come towards him. The Path called and he surrendered. In the middle of the pack he ran as he'd never run, hurtling down slippery slopes, across the undulating mountainside, feeling the sharp sting of stones under his paws, a symphony of

Simply trusting, he let himself go, tail waving free, the breath of the wind swelling his lungs.

sensations pulsing through him. He gave no thought to where he placed his paws; he ran too fast to think.

Simply trusting, he let himself go, tail waving free, the breath of the wind swelling his lungs. And the fir trees parted to let him pass.

For the whole pack, the thrill of being alive in this moment was stronger than the fear of being heard. Defiantly they cried the forbidden words: 'Here – I – a-a-aaam!'

The earth itself began to tremble beneath them, the whole forest tossed and swayed. But they hardly noticed. Like arrows they shot out of the forest into a barren clearing in

the exact moment that a set of huge rocks sprang to life and began tumbling down the mountain. In a desperate attempt to dodge them, Kalu used his extraordinary strength to accelerate even more. Too old to keep up, Muni maintained the same pace and the Dog stayed behind him, followed by Alina and Anah.

Fate has its own agenda, however, and as one of the boulders hurtled down it crashed against another rock, changed its course and went chasing after Kalu. It hit him squarely on the side. The black wolf somersaulted through the air and plummeted down the ravine.

As the cloud of dust subsided, his companions rushed to find him. His eyes could no longer see them; his ears could no longer hear when they called his name. Kalu was gone.

All that was left were his flesh and bones, covered in a fine black coat.

'Let's go,' said Alina to the Dog. 'What are you waiting for?'

The Dog stood stock-still, stunned. *Where did he go, that friend I knew?* he was asking himself. *We were getting on so well just a moment ago! Every hair on his body is untouched, his eyes, his four paws, his tail are all still there. Yet the Kalu I knew is – gone. Something that lived inside him, lighter than air, has flown away. That, then, must be the most precious thing of all, which exists in me too, and I must value it above all else . . .*

Suddenly the Dog felt that nothing would ever feel as carefree as it had on that summer's evening when they'd set off together on the Path. The days were pleasant still, but the autumn nights had developed a bitter note and now a cold breeze blew, making him shiver.

When the earth had stopped quaking, peace returned. The stars shimmered in the sky, bright and tranquil as ever – till a black plume of smoke rose to blot them out. Beyond the valleys and the hills, the Dog's gaze found the City that he'd just left. Its myriad lights had gone out. Then, like giant hungry tongues, he saw the flames leaping wildly over the shattered palaces.

Over there some rocks had fallen. Over here a friend had died. In the distance a city had crumbled. But the mountains still stand.

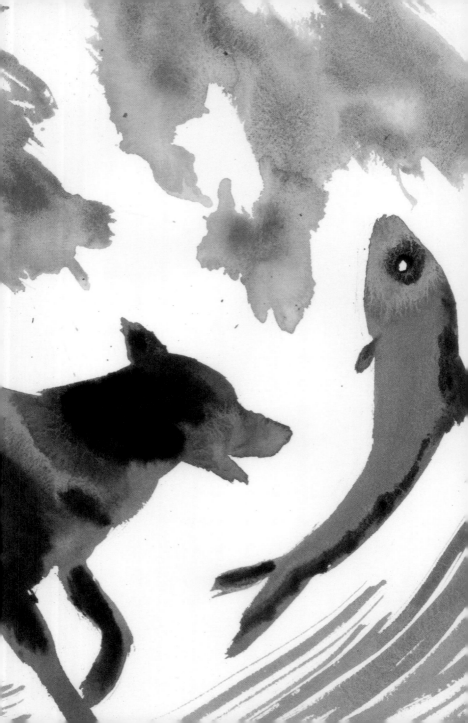

CHAPTER NINETEEN

Hunger

A new wind was blowing from the north. It brought the scent of pine forests, and snow. The Dog smelled it when he closed his eyes. The trees too knew it was coming and were preparing for it in their own unusual way, changing the colour of their clothes before disrobing completely. The woods were filled with the whisper of falling leaves.

It had been a long while since they'd spotted any human settlement. They'd travelled up the spine of an interminable chain of mountains and when those mountains finally subsided into a vast plain the pack found itself in a place of lakes and marshes, shrouded in fog. Water was everywhere, but animals were scarce, apart from huge flocks of birds, impossible to catch.

The loss of Kalu the Brave weighed heavily on them. It was he who had always been most skilful at surprising his companions with mouth-watering meals.

Now and then, through the swirling fog, they caught sight of thundering herds of animals with heavy hoofs and dangerous horns, but they were far too threatening for three lean wolves to face, with a Dog still trying to learn the art. A whole week could go by without them securing a square meal. Then hunger would tug at their stomachs. But it was precisely this state of being hungry, hungry as the wolf, that freed their minds from any fear and pushed them on the offensive with absolute determination. Woe betide whatever creature crossed their path then!

When meat was nowhere to be found, when there wasn't even a dirty mole to catch, the wolves made do with lesser alternatives. Fortunately there was Muni, whose seemed to know not only the name and nature of every animal, but every type of plant too. One evening, in hushed tones, Alina told them Muni's story. She claimed he had travelled around the whole world, alone, without a pack, with nothing but his head and his tail and the fur on his back. 'You see,' she concluded, 'the more you know, the less you need!'

Mushrooms had sprouted up from the earth. Only Muni knew which ones were edible – the brown ones, which were almost invisible among the leaves; and which were poisonous – the ones with bright, inviting colours. One time Muni even made them dig a hole in search of tubers, which they chewed to chase the hunger away. Embarking on a rare explanation, the ageing wolf recounted how years back, instead of attacking a wise old boar, Muni had shadowed him for days, watching and learning his most secret habits.

'If those underground tubers were so prized by the boar, I thought, perhaps they would also be good for the wolf. We aren't that different, after all.'

'Too true, too true, Muni,' said Anah, always filled with respect for the elder.

One day, when the Dog had gone ahead to scout out the lie of the land, he spotted a flash and a shimmer in one of the many lakes. He crept stealthily along the bank, froze, waited patiently, then dived in, head first. The fish fought desperately to escape, spraying water everywhere, but the

> *He crept stealthily along the bank, froze, waited patiently, then dived in, head first.*

Dog's jaws managed to haul him out and toss him onto the shore. The Dog couldn't bring himself to kill yet, but each time the fish tried flapping back to the water, a paw pushed him back towards the land.

Such a big, beautiful fish would be a fine treat indeed! And the Dog happened to know that it was also Muni's favourite dish so, bursting with pride, he left the prey there and hurried to call his companions. A rare moment of sunshine had come, so he found them slumbering on some rocks. Unable to rouse them, the Dog decided to lie down by their side, without saying a word about the surprise that awaited them.

He was just beginning to enjoy this moment of peace and quiet when an ugly and irritating squawking began.

'Caw-haw!' replied a feminine voice.

The Dog cocked an ear.

'Caaaw!' said the first voice again.

'Caw-haw-haw!' continued a third.

'Caw-haw-haaaw!' agreed several others, joining the discussion.

His curiosity piqued, the Dog listened more attentively and, lo and behold, he almost thought he was catching the gist of what they were saying.

'Caaaw-on, let's gaaaw!' said the first voice, rising above the others. 'Before they wake up, those lazy daaawgs!'

The moment he saw the gang of crows take flight, the Dog leapt to his feet, barking fiercely, and ran as fast as his legs would carry him towards the lake.

Too late!

The crows had seized the fish and, in a flutter of dark wings, were already hauling it away into the sky. With a last, desperate leap the Dog managed to catch the wing tip of the slowest crow. A white eye stared back at him.

Just then Muni and the others, who of course had been woken by the Dog's shouting, arrived on the scene.

'Thieves!' barked the Dog. 'I caught a great fish for you, Muni, and those thieving birds have made off with it.'

The captured crow fluttered indignantly, but the Dog was so beside himself with rage that he was about to break its neck.

'Let gaaawwww!' protested the crow.

'Let him go!' said Muni. 'That's Odin, their leader.'

'What are you cawing about, you horrid bird?' said the Dog. 'Always hot on the heels of Death!'

'That I am a follower of Death, I won't deny,' replied Odin, and the Dog realized with surprise that he could understand him as well as if they were speaking the same tongue. 'What finer teacher is there, after all, to make us appreciate the miracle of life? But despite my funereal appearance, I've never personally taken the life of any creature.'

His good eye flashed at the Dog.

> '*Oh, let me teach this filthy scavenger a lesson!' cried the Dog in exasperation.*

'That dirty work I leave to others,' he continued. 'We crows do the cleaning-up, picking meat off bodies that are already dead. It's you, the wolves, who are the princes of the forest. Once you've completely gorged yourselves, if you're kind enough to leave a few scraps behind that's more than enough for us. We don't ask for much. Having to fly, you understand, we have to watch our weight!'

'Oh, let me teach this filthy scavenger a lesson!' cried the Dog in exasperation.

'Aaaw, filthy? A lot cleaner than you, I am!' retorted Odin. 'I've had my eye on you – saw you, refusing a bath in the river! As for me, I may be pitch black from the top of my

beak to the tip of my claws, but mine are the robes of the high priest. You should show some respect!'

'Bah, respect for a thief? You and your gang of thugs, always hidden in the leaves, waiting to steal a piece of our hard-earned prey.'

'Oh, a thief too now, am I? Didn't you tell him, Muni, who it was that provided you the herd of deer when you were going hungry? Who guided you, dear Dog, to catch that doe, your very first prey?'

'It's true,' said Muni. 'You haven't understood this yet, but the crows are our allies, they're our eyes in the sky.'

The Dog was dumbfounded. So that's how Muni had been able to see through the mountain on that moonlit night!

'Come on, let him go,' said Muni. 'What use is that bundle of feathers and bones to you? He'll just get stuck in your teeth.'

It was only because Muni asked him to that the Dog spared the life of that wretched scoundrel, that gloomy beggar with the voice of a goat. Reluctantly he opened his jaws and let Odin, crooked and rather the worse for wear, fly off to join the rest of his gang in the sky.

The wolves made the best of a bad situation. With empty stomachs they went back to sprawl like great big lizards on the rocks, feeding off the shimmer of the sun's golden rays.

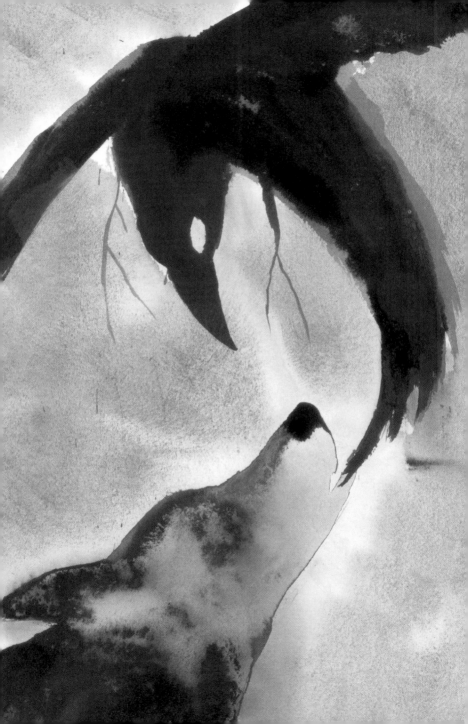

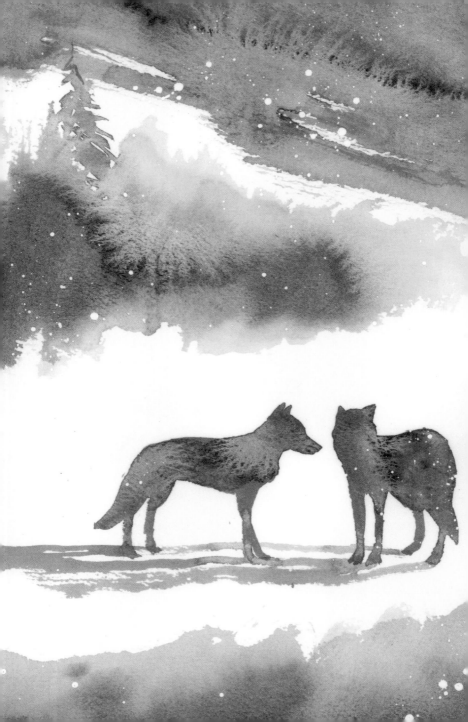

CHAPTER TWENTY

The Vision

The fish had flown away, but not the hunger. They'd lost the only prey they'd caught in over a week and pangs of starvation gnawed at them. Yet night after night the pack met nothing but wind and cloud. The same hunger that had once strengthened their souls now weakened their bodies. Doubt crept into the pack. They slept longer. Struggled harder to wake up. Ran more slowly. Stopped more frequently.

One evening, as the pack was wearily preparing to set off again on the Path, Alina announced she would not be coming with them.

And Anah, to everyone's surprise, added that he was leaving with her.

'Winter is approaching,' he said, with a hint of embarrassment. 'Not that I'm afraid of snow, of course, but what's the point of continuing now? It will only get worse

from here on; we'll find nothing but a hard, frozen expanse. I've heard, instead, of a huge forest of silver birch trees, to the east, where humans are scarce and animals plenty. Maybe there we can find a place ...'

'To make a den,' said Alina, finishing his thought. 'I know, we set off on this pilgrimage together. But Moon Mountain always seems to be beyond the next valley, behind the next ridge. We're always almost there and yet we never arrive.'

'We want to make a home, and our own pack now,'

'But Moon Mountain always seems to be beyond the next valley, behind the next ridge.'

continued Anah. 'A family.'

'Maybe in springtime we could resume this journey,' concluded Alina.

'Oh, in springtime you'll have other things to think about!' said Muni tenderly. 'And there is nothing more precious than those.'

The Dog didn't feel the slightest envy at discovering that Anah had conquered Alina, or she him, and that the two were leaving together. On the contrary, he was happy for the cubs they would soon be raising free in the woods.

Alina and Anah bowed their heads down to Muni's paws.

'Who knows,' said Alina. 'Maybe one day I shall return to the Ancient Path.'

'When you have had your pleasures, when you have fulfilled your duties, you'll find the Path again, if you really want. Remember, it's always there. It always begins in the very place where you're standing.' Muni brushed their foreheads with his nose. 'Run along now!'

It had started to snow when Alina and Anah set off, side by side, vanishing like bride and groom into the swirling vortex of flakes.

The cold had become so bitter that Muni and the Dog – the last two vagabonds of the pilgrim pack – slept huddled together in whatever half-sheltered place they could find. More than once the Dog wondered if they weren't just two deluded fools looking for something they'd never find.

After weeks spent crossing a seemingly endless plain, they discerned new shapes on the horizon. Hills. One chain of hills rose behind another, and then mountains, with ever taller peaks leading like a stairway to the sky, disappearing into the clouds.

Drifting in and out of a troubled sleep, the Dog saw the clouds slowly parting until a most wondrous vision appeared. Above the plain, above the hills, above the mountains, above the highest peaks, above the clouds, totally still among the curling mists, it radiated harmony and eternity. Could a land so high really exist? With its five snowy peaks, the Mountain floated like a castle in the sky,

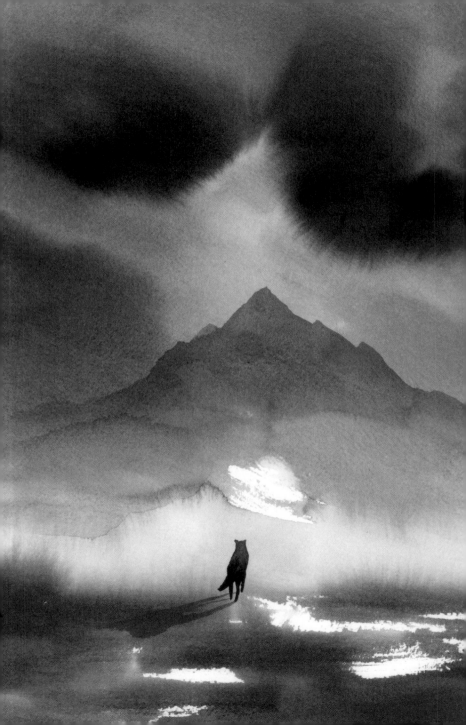

perfectly pure and white as the moon.

The Dog froze in awe: there was no doubt what it was.

He reached out a paw to shake Muni awake, but as his companion opened his eyes the veil of clouds closed again.

'Yes, I believe you saw it,' whispered Muni. 'It's there. But it wanted to show itself to you alone.'

'To me? Why?'

'What do we ever know about the whys?'

They had travelled huge distances in pursuit of this destination, but now that the Dog had caught a glimpse of

'Yes, I believe you saw it,' whispered Muni. 'It's there. But it wanted to show itself to you alone.'

it, he felt it was more unreachable than ever.

'It does not belong to this world. It's too high, suspended up there in the sky . . .'

The old wolf nodded. 'And if it looks so perfect from down here, imagine what the view must be like from up there. Maybe it would really be like seeing through the eyes of . . .'

The Dog didn't catch the last word, nor was he quite sure if the wolf had said it, or if he'd just emitted a peculiar sound, something between a sneeze and a sigh.

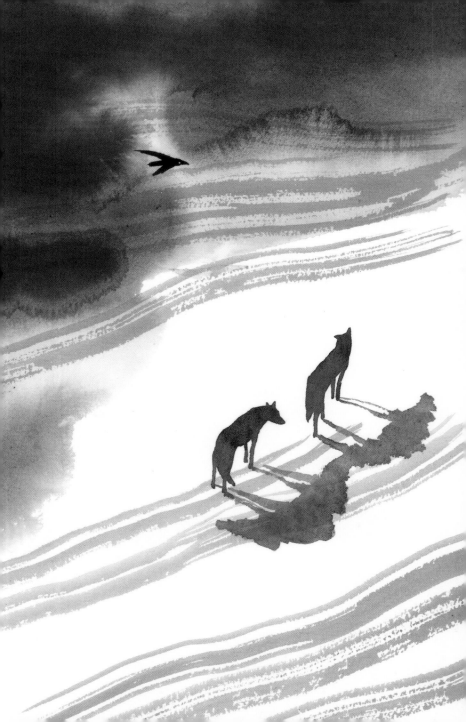

CHAPTER TWENTY-ONE

Goodbye

Now the Dog was alone with Muni. He accompanied him with devotion, following precisely in the footprints that the wolf left in the snow. Nothing gave the Dog more joy than walking behind that old fellow with aching paws. It was peculiar how much the Dog loved him. For a youngster like him it might have been more natural to want to spend his days and nights with an attractive she-wolf, like Alina. Instead, he liked to observe the sparse efficiency of the old wolf's movements, or the ever more distant look with which those eyes greeted everything that came their way, or didn't.

Muni spoke less and less. Frequently he betrayed signs of fatigue. The Dog took every opportunity to serve him, bringing him the relief of a mouthful of bitter healing herbs, which he'd mix with sweeter flower buds, less healthy perhaps, but which Muni devoured eagerly. Once

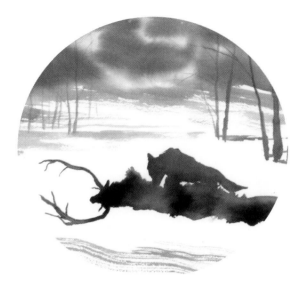

the Dog even managed to obtain for him some scraps of meat from the decaying carcass of a deer.

While previously, when he lived in the City, the Dog had been proud of his youth, now he saw the beauty of old age, that shining beauty which good grandparents have, or ancient trees which, after a thousand seasons have wrinkled their bark, are far more fascinating than when they were fresh and green.

One morning even the crows, who had followed the expert hunters since the beginning of the journey, decided to abandon them. There simply weren't enough leftovers anymore. They turned tail and flew back, becoming tiny specks that vanished in the distance.

'About time!' muttered the Dog.

Once in a while, though, the wolf and the dog would spot a single black dot. In order to continue following them, the bird made do with eating the excrement they left behind.

'I swear that must be Odin.'

'Are you two friends?' the Dog asked Muni.

'Hmm, you could say so. Odin has been with me forever. And before me he followed and instructed my mother, and before her my grandmother, and even my grandmother's grandmother.'

'That's impossible!'

'Not at all. You see, those "ugly birds", as you call them, live ten times as long as a wolf.'

Muni's health had taken a turn for the worse. One evening, waking up as always shortly before sunset, the Dog found him still curled up on the ground, covered in a thin layer of snow. Something was wrong. When had Muni ever failed to say goodbye to the departing sun?

The Dog let him sleep on, waiting patiently by his downwind side to shield him from the sting of the air. As soon as the wolf opened an eye, the Dog spoke.

'Tell me, Muni, is there anything you need?'

'Need?' said Muni, with a faint smile. 'What should I need?'

He was always so perfectly complete in himself. His eyes closed again.

'And yet I sense you're unwell,' insisted the Dog. 'I've never known an evening when you didn't rise for the sun …'

'My legs have become heavy. I feel the earth pulling me to her, as if she doesn't want to let me go.'

'And it's been a while since I've heard you sing the Song.'

'It's true, I'm almost out of breath.'

A deep silence fell between them.

'My dear brother,' continued Muni with some difficulty. 'There's something I must tell you. In three nights I am leaving.'

'Leaving, Muni?' asked the Dog in consternation. 'And where are you going? Aren't we supposed to reach Moon Mountain together?'

Muni shook his beautiful head, decorated with white hairs. Then the Dog finally understood and big silent tears welled up in his eyes.

For three days he attended to the wolf, who didn't budge from where he lay. Once in a while the Dog went to a stream, filled his mouth with icy water and brought it back to Muni to moisten his throat. Muni asked for nothing more than that.

'Things never go quite as we imagine them,' said Muni. 'When I'd seen enough of the world and all that was left was Moon Mountain, which I'd heard much about, I set off with my four paws to find it. One night I came across a lone she-wolf who, seeing this old wanderer who'd taken to the Path, decided to follow me. Together we met Kalu the Brave. Then Anah. Finally you showed up. You took us by surprise: what was a dog, naive and companionless, doing

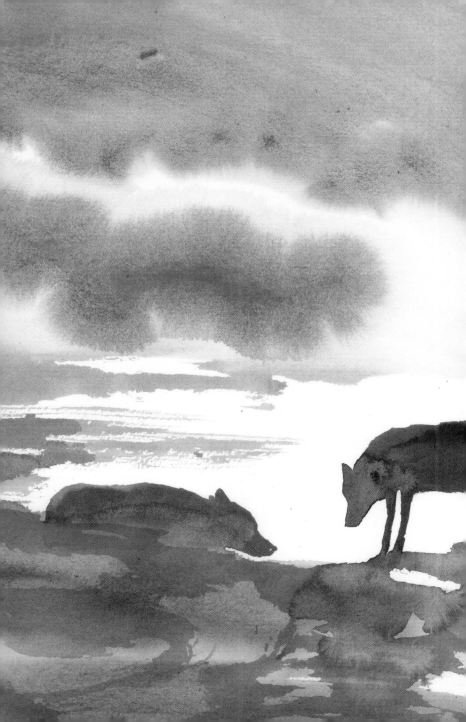

in the middle of the forest? You were lucky we were pilgrims and not an ordinary pack of wolves or we'd have had you for dinner. But right from the start I sensed you had something ... More than any wolf I'd ever met, you knew devotion. You always blindly loved your Owner. You have a gentle soul; you are humble, loyal and constant in your determination. And whoever can love with such purity an owner who is not worthy of it, sooner or later will find the love of that which is worthiest of all.'

'What's that?' asked the Dog.

> *'Now you're at the foot*
> *of Moon Mountain.*
> *You believed I would*
> *bring you here.'*

Muni smiled.

'Now you're at the foot of Moon Mountain. You believed I would bring you here. Though for you the Path was even more arduous than for the others, though you had many doubts and complaints, you stayed on it. I didn't seek you out, nor you me. Our ways just happened to cross. And listening to your story, hearing with what naive simplicity you were trying to reach a goal so distant and so high, I knew at once I had to help you. Now you are almost there. Go!'

'But Muni, how can I go on without you?' said the Dog.

'When I met you I was just a stupid dog. Because of you, everything has worked out.' His eyes shone with sincere gratitude. 'Without you I would surely have died. You were my guide.'

The wolf shook his head.

'I am just a pilgrim you met along the Path,' said Muni. 'Don't you remember the Waterfall, the Lightning, the Giant Tree, the Doe . . . ? You have had many guides. Perhaps one of them was also an old wolf!'

The Dog was moved by these words.

'But how can a poor dog go where even the strongest wolf, the fastest wolf, the most intelligent wolf cannot reach? Give me one last piece of advice!'

'Don't ask "How?" There is no wolf, no animal at all that can survive up there. Not even the trees live there, not even the grass. Up there, there's nothing but stone and ice and death. If you want to reach Moon Mountain, just go. Go until you can go no further – and then keep going!'

'But . . .' The Dog felt a terrible sadness seeping into his heart. He couldn't bring himself to leave the wolf. One last time he tried to persuade him: 'You and I have come so far together, Muni. Don't you want to reach the top of the Mountain?'

Muni sighed. 'More than any other destination, Moon Mountain is the one I always sought. It is the journey each of us was born for. My body is too old now, though; it can no longer carry me so high. But when I have left this body, then I shall surely go there!'

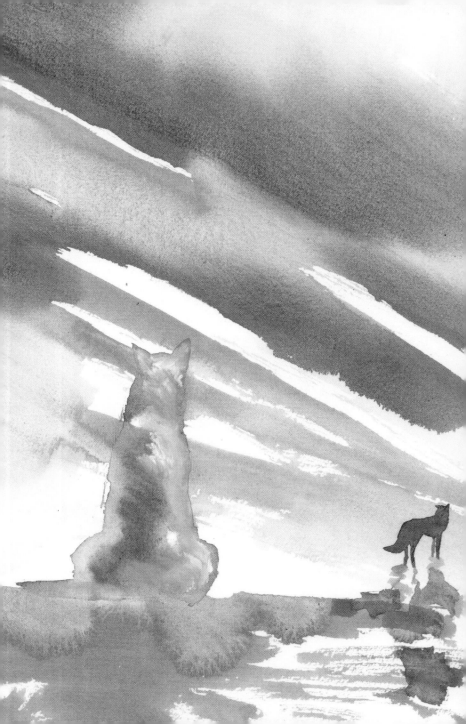

CHAPTER TWENTY-TWO

Moon Mountain

When the Dog had set off on the pilgrimage it had been summer, the trees laden with fruits for all living creatures. Then autumn had come. The fruits had fallen off the trees, the berries had shrivelled in the twisting brambles, the nights had grown long, the days short and a wind that tasted of snow blew in from the north. The animals had descended from the high peaks in herds, in couples or alone, and now they had all vanished.

The heads of the mountains had turned white. Up there not even the trees, so strong and patient, dared to grow. Even the grass that covers the meadows had turned yellow and retreated back into its roots, hiding beneath the mantle of the earth. Even the torrents of water that had once leapt and gurgled from the mountain had frozen into deathly silence.

The journey had been long and now it was too late.

The Dog cast one last look at the frozen statue Muni had become. Then he turned to face the Mountain. Gazing up those giddy slopes that vaporized into clouds, the destination seemed unreachable, pure folly. But he'd made a promise to himself.

As soon as he turned his back on Muni, the storm began. There are storms that arrive with rumbles of thunder and squalls of wind. This one began with a gentle snowfall. During the course of the pilgrimage his body had dried out, the fur on his back had thickened and the pads of his feet had hardened. He no longer feared darkness and night, but had come to love them too. His ears understood the news of the birds. And hunger had taught him the art of the hunt. But how could all this serve him, if up on that mountain there was no life at all?

The higher the Dog climbed, the heavier the snow fell and the angrier the wind blew. The flakes no longer drifted down gently from the sky, but lashed him horizontally, stinging his face like a swarm of angry bees. Oh, the Dog knew that the weather can change, but he hadn't expected a blizzard like this. Without a single tree under which to hide he tried cowering among a cluster of rocks, waiting for it to blow over. It grew worse. The rocks proved such poor shelter that it was better to get out and keep moving, to generate heat. On stiff, frosted legs he trudged on.

Squinting through half-closed eyelids he made out a dark line snaking towards him. *A stream*, he thought, recognizing it at once. *But there's no way I can cross this,*

it'll sweep me away.

He stopped on the bank, shivering and frightened. *If you want to reach Moon Mountain, just go. Go until you can go no further – and then keep going!* So he did the only thing left to do – he jumped . . . and suddenly found himself bounced across to the other side. Without even turning to see if he'd put a paw on a slab of ice, he continued to push through the storm.

His thoughts mixed with the air, forming shapes in the fog that were there one moment, gone the next. Glittering

These are the rocks that twinkle like jewels and melt when you put them in your mouth!

walls of ice loomed in front of him. He slipped, picked himself up, fell again. Ice and snow filled his mouth and he was almost suffocating - until they started to melt.

These are the rocks that twinkle like jewels and melt when you put them in your mouth!

Suddenly the ground stopped rising.

He had arrived.

He had reached the top of Moon Mountain.

The Dog stopped. And waited. He waited some more. Waited for something to happen. He opened his eyes wide, but there was no one and nothing. Nothing but whiteness.

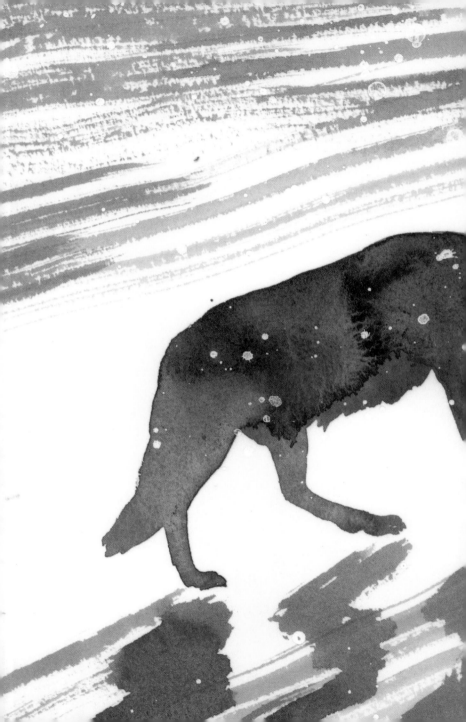

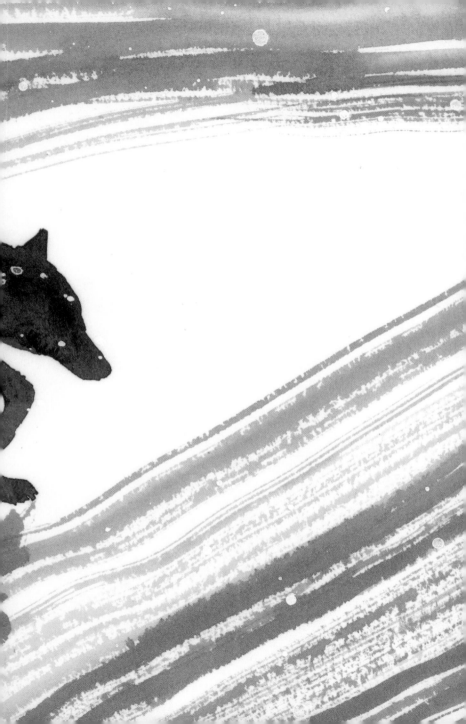

Infinite whiteness. It was neither day nor night. There were no shapes, no smells, no sounds. Nothing, nothing, nothing. Even the wind had subsided. Snow and cloud, earth and sky, everything was the same, everything was white. The Dog had imagined this place as the fountain of life, the source of all things. Nowhere could have been emptier or more desolate.

Did I come all this way for nothing? he asked himself. I really am a stupid dog!

His paws finally gave way beneath him and he collapsed

'Now you're at the foot of Moon Mountain. You believed I would bring you here.'

into the vast white bed.

After a while the fog begins to clear.

An eye appears. A big round eye. It's looking directly at him.

'Who's there?'

He remembers the ends and the beginnings of days. *Is that the sun? But it's so pale. So mortally pale. It gives off no warmth. Is this the Land of the Dead? Am I already dead?*

He surrenders to the emptiness, the silence, the nothingness.

Sleep. Sleep . . .

Time passes. Then there's something that's not nothing. It's faint, very very faint, as if it's coming from far away. But it is not nothingness. A memory stirs. Home. His Owner is tickling him behind the ears . . . Or is it his Mother, who he barely knew, licking the snow off his coat . . . No, it's not Mother either . . . A multitude of loving fingers caress his fur. Rays of love and light.

The Dog turns. At the opposite end of the sky, through the fog, a second eye is gazing down at him. Like the first one, but different – golden.

That's the sun! Then the other pale eye must have been the setting moon. And I'm still alive. Oh, the infinite bounty of nature! On top of Moon Mountain the sun is rising!

Below, the storm continued to rage. Up here stillness reigned. The Dog let that gentle, luminous warmth revive him a little. Then, with a huge effort, he pulled himself to his feet and found himself standing on the summit of a white island, floating on a sea of clouds. It was in that very moment that the realization came:

There *is* Something!

One morning I found myself naked, alone and abandoned. I had nothing, nothing at all. Then a Wolf appeared and gave me a leg of meat, saying, 'Go on a pilgrimage to Moon Mountain. And when you reach it you will know if there is Something, or not.'

I set off. But by the end of that first day the food was already gone. That's when the pilgrimage really began. The way was much longer than I imagined. Yet, in the end, it turned out exactly as the Wolf with golden eyes said. I made it.

I'm here, I've arrived. But how did I do it? Because every

day I received everything that I needed. There were rivers to drink from, and all kinds of meats and grasses and berries to eat. I found comfortable resting places of moss and leaves, and hard beds of stone. Without my even asking, fireflies came to light my path and trees gave me shade. I saw spectacular sights, inhaled the fragrance of flowers and enjoyed the songs of many creatures I encountered along the way. As if by magic, each day I received countless gifts. From where? From who?

But what its name was, he couldn't say. He knew, though,

'I'm here, I've arrived.
But how did I do it? Because every
day I received everything that
I needed.'

for certain, that there was Something. *Something unspeakable that looks after every living creature who, like me, wakes up every day with nothing – and depends on it entirely.*

He had never had this trust before. Now he'd found it.

But the very same instant he understood this, the Dog also realized that he'd pushed himself too far. The cold, the ascent and his hunger had utterly consumed his body. He could hardly stand, he couldn't take even one more step.

I haven't got the strength to go back down the mountain, he thought. *Everything is perfect, except that now I must die.*

Ploffff!

A black blotch fell from the sky into the perfect whiteness. It stirred, stood up, shook the snow from its feathers ... It was Odin, the leader of the crows!

'What on earth are *you* doing here?'

'I was about to ask you the very same thing,' answered the crow. 'I am old now and all I wished for was to get away from that bunch of rowdy birds and retire to a quiet place. So I let myself go to the winds of the storm until higher, higher, higher still, they threw me onto this desolate mountaintop. And then – surprise – I find you here!'

'This is very strange indeed,' said the Dog.

'It must be a good omen; and therefore I must ask you a favour.'

'Certainly, my dear Odin. Even though I'm at the very end of my strength, whatever I can do for you . . .'

'Personally, I have never killed, but all my life I have eaten other creatures,' said the crow. 'I have swallowed great quantities of frogs and worms, and the eggs of birds still unborn, and snakes and grasshoppers. I have taken advantage of the corpses of large beasts and even – I'm ashamed to admit – of some little wolf cubs too. How many creatures had to die so that I could live! This thought has often troubled me. So, at last, I have decided to give something back—'

'Absolutely not,' interrupted the Dog. 'I don't want to hear about it!'

'Would you deny a poor crow his last wish? I only regret that I'm rather scraggy and not as tender as I once was. But I ask this of you: leave me in peace for a while, as I die, to contemplate this magnificent view one last time. Then you must eat me so you'll have the strength you need to go back down the mountain.'

The old crow and the Dog burst out laughing.

It was a perfect plan. There was nothing more to say.